INVENTORY 1985

10/29/75

INVENTORY 1985

INVENTORY 98

SCULPTING
IN STEEL

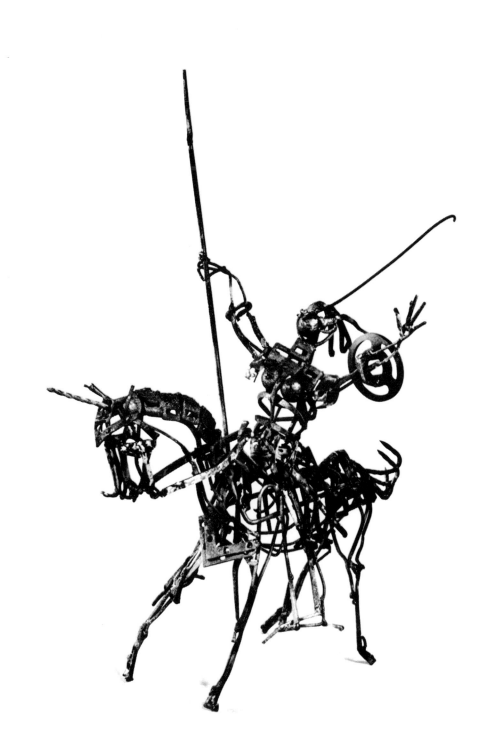

SCULPTING IN STEEL and other Metals

Arthur Zaidenberg

Chilton Book Company/Radnor,Pennsylvania

Copyright © 1974 by Arthur Zaidenberg
First Edition All Rights Reserved

Published in Radnor, Pa. by Chilton Book Company
and simultaneously in Ontario, Canada,
by Thomas Nelson & Sons, Ltd.

Library of Congress Cataloging in Publication Data

Zaidenberg, Arthur, 1903-
 Sculpting in Steel and other metals.

 Bibliography: p.
 1. Steel sculpture. 2. Metal sculpture.
I. Title.
NB1240.S7Z34 1974 731.4 74-1086
ISBN 0-8019-5829-6
ISBN 0-8019-5835-0 (pbk.)

Designed by Cypher Associates, Inc.
Manufactured in the United States of America

Foreword

The purpose of this book is to introduce the novice to the various methods of "drawing with steel"—creating modern metal sculpture, whether the creation of the work involves simply bending steel wire or it involves the more complex processes of welding steel rods and plates. I present a general survey of works achieved by using such materials, methods and techniques as are employed by myself, the sculptors with whom I have worked and those whose sculpture has interested me.

There are many welder-sculptors whose experience in welding techniques is far greater than mine and whose interests and creative purposes differ from my own. It would be presumptive of me to attempt to teach their special approaches to their art. However, it is my fond hope that if the novice practices the methods presented here he will be prepared to experiment and thus to develop those special techniques that will enable him to embody his artistic flights of fancy in metal sculpture. If this hope is realized, his enjoyment of these creative processes will soon equal my own.

Acknowledgments

I wish to express my gratitude for the artistic and technical advice given me by Tommy Beere, Lothar Kestenbaum and Walter Weber.

I also wish to thank the Union Carbide Corporation, Linde Division and the Companie Gases Industriales de Bajio S.A., Mexico for technical aid and the loan of photographs used in this book.

Contents

List of Illustrations

Color Plates

Introduction

The word "drawing" may seem a contradiction to the very nature of sculpture, for sculpture has traditionally been restricted to the carving of solids—stone, wood, ivory or bone. When sculpture is modeled, clays of many varieties are used, some baked to harden them, others used as base materials to encase a clay model. This case, when emptied, becomes the receptacle for casting sculpture in molten metals: bronze, copper, silver, gold and many alloys. Although drawings, as preliminary sketches for the concept, are often made in connection with sculpture, the usual sculptural media have rarely been considered suitable for work in linear patterns. Occasionally, sculpture has utilized bas-relief or intaglio work in which lines are either raised or etched, but for the most part the sculptor has concentrated on modeled, solid form rather than on pure line.

Perhaps inspired by the beauty of the delicate machinery, exquisite suspension bridges and lacy steel towers constructed by modern engineers, sculptors began to experiment with the possibilities inherent in linear sculpture, and began to use soldering and welding tools to hold the various pieces together. This widened the range of creative possibilities far beyond those of two-dimensional drawing on paper. A vital medium for sculptors that offered an exciting departure from the restrictions of conventional solid-form sculpture was revealed.

This book will deal with the methods of creating such linear sculpture in metal, demonstrating the processes of bending, forming and joining metals by using various soldering and welding tools. In permanent metal, the student may "draw" three-dimensional concepts that could be realized only two-dimensionally on paper before the advent of these new and modern techniques.

Some Further Thoughts

The professional artist invariably resents the suggestion that any creative process is easy to learn. This response is, perhaps, a natural one. Having spent virtually his entire life dealing with the vast complexities of his medium and having felt the severe pangs of the creative process, the artist, when he hears that "anyone can do it" or that such accomplishments are "easy," quite properly feels that his inspiration and hard-won craftsmanship are being belittled.

My books, including this one, have never intentionally belittled either the creative process or the artist. Respect for the accomplishments of the dedicated artist is, indeed, one of the prerequisites for the proper study of painting or sculpturing. However, just as the concert pianist does not begrudge the pleasure gained by amateur pianists who study and perform for their own pleasure, so the "pro" painter or sculptor should bear with the amateurs in his field who are trying to express themselves within the limits of their learning and talent. Unlike the performance of brain surgery or the building of suspension bridges, for which the highest professionalism is necessary to preserve human life, the pursuit of the arts for one's own satisfaction causes little damage in comparison to the pleasure obtained and sometimes given.

This note is not intended as an apology for the amateur, rather, it is a word of homage to the professional artist who lives a full-time creative life. It is, as well, a plea to the "pro" for tolerance of the happy amateur who, in

time (who knows?), may achieve the stature of the true artist—of such individuals there can never be enough.

In this book, the subject presented to the novice falls outside the relatively harmless amateurism of the beginning painter or sculptor using traditional media. There are dangers inherent in the medium dealt with in these pages that, while not great, may still be considerable unless a professional attitude is cultivated from the outset. However, every creative activity has some inherent danger to life and limb: chewing on lead pencils or oil-painting brushes may cause poisoning, a violently handled palette knife may injure an eye or a slipped chisel may damage the sculptor's anatomy. For drawing with steel, the precautions normally observed by anyone who uses cutting tools or an apparatus for heating metals are necessary, along with a few extra, and duly noted, considerations.

SCULPTING IN STEEL

The Welding Method

The welding process has such obvious merits for sculptural use that it is strange that it has gained popularity only in relatively recent years. The fact that it allows a sculptor to work directly in hard metals makes it most desirable as a medium for the creative artist. The welder-sculptor need not call on professionals who possess elaborate forges to produce his finished work for him; he can do it himself.

The process is so simple and direct that only a minimum of technical instruction is required before the beginning sculptor may begin to express himself creatively. The basic principle is that of using a hot flame to melt and fuse the "melted" edges of two pieces of metal. Acetylene and oxygen, flowing from separate tanks, are mixed and when ignited produce a flame of intense heat that will melt and fuse most metals. When the pieces of heated metal are joined and then cooled, they are strongly and permanently bonded together.

Now that we know the basic principle of the welding process, let us examine just what is to be studied in this book—what the beginner will need to know about materials and basic operations in order to launch into the fascinating process of creating welded metal sculpture, the process of drawing with steel.

First let us see what work space and equipment are necessary to handle the materials both efficiently and safely.

The Work Area

Nothing could be more desirable for the sculptor than a large fireproof studio totally devoted to the metal-welding craft, one with no stairs to climb when carrying heavy materials, equipment or finished sculpture. However, hundreds of sculptor-welders work in far less than ideal surroundings and still manage to produce fine pieces of sculpture.

For most purposes, a corner of a room cleared of flammable objects unrelated to the sculpture can serve as a comfortable work area for all but the most massive sculptures. The walls in the immediate vicinity of the acetylene and oxygen cylinders and the workbench should be protected by sheets of light metal or panels of asbestos. A nearby open window will provide adequate ventilation. A concrete floor will provide a good fireproof base, but if your floor is wooden, cover it with a thin sheet of light-weight metal extending well beyond the area you plan to use. This will eliminate the danger from sparks. A fire extinguisher should be kept at hand along with a pail of water. The water is used for cooling overheated tools and rods and as an auxiliary fire-quencher. Try to obtain a stong metal table, but if you can't find one, cover the top of a wooden work table with a sheet of steel.

A word of caution: There is no need to be afraid to use a torch as long as you bear in mind that careless handling can result in burns and even start a fire. Neglecting to observe a few simple safety rules may have regrettable results. Be sure, therefore, to take all possible precautions so that you can enjoy your work and create with a tranquil mind. Constant alertness and

care at the outset will result in the safety habits becoming a part of you. If the necessary rules are observed there will be no more danger from sparks and the torch flame than there is in cooking in a kitchen or barbecuing a steak on the terrace. The welding process is not a dangerous one—it merely requires the observance of simple, intelligent safety precautions.

Because fire laws and restrictions vary from locality to locality it is well to explore them carefully before you begin to make sure that your work area is within the law and meets all insurance regulations.

The Equipment Needed

It is both convenient and economical to lease cylinders of oxygen and acetylene from a welding supplier in your area. Most dealers will deliver tanks and pick up the empties for refilling. This is a great convenience because the tanks, empty or full, are extremely heavy. The terms will vary with the size of the cylinders you use and the supplier with whom you deal. However, the cost of the cylinder rental, the oxygen and the acetylene is not high and probably will not exceed the outlay involved in buying tubes of good oil paints, canvas and brushes to make a painting.

A kit of basic welding equipment is adequate for most light-welding sculpture purposes. The various parts are light in weight, an important consideration, and with proper care will last a sculpting lifetime. The cost, variable according to the manufacturer, is not great. About one hundred and seventy-five dollars will provide a good and complete equipment kit.

You will need the following things (see Fig. 1):

1. A workbench—table height, metal or topped with a sheet of steel.
2. A small vise.
3. Several clamps—to hold parts allowing both hands to be free for welding.
4. Pliers—several sorts.
5. A hammer—to straighten rods too thick to bend with hands or pliers and for use instead of the torch.

4

6. A leather apron—homemade or purchased, to protect your clothes and body.
7. A pair of leather gloves—gauntlets preferred, to protect your hands.
8. Metals—the various metals needed will be dealt with later on.
9. A first aid kit—burns are hazards of the occupation, so have the necessary unguents on hand.

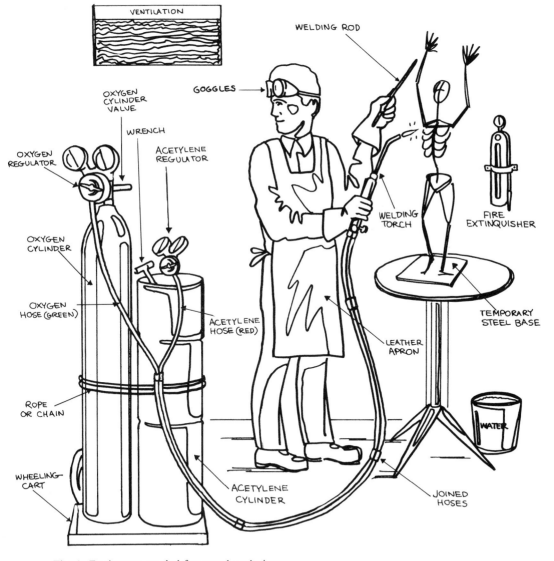

Fig. 1. Equipment needed for metal sculpting.

The Cylinder Systems

CYLINDERS

Acetylene and oxygen cylinders are available in several sizes (see Figs. 2 and 3). All but the smallest sizes are too cumbersome for easy handling, and the smallest size is practical only for welding very small sculptures.

Wheeled carts are advisable, both for safety in shifting the position of the cylinders and for saving one's back and muscles. Carts are not expensive (from about fifteen dollars upward), and they will most likely be available through the supply house that furnishes your cylinders (see Fig. 4).

REGULATORS

Although you can rent your oxygen and acetylene cylinders, the regulator for each cylinder must be purchased. Regulators are needed for bringing the two gases out of the cylinders and mixing them. You will need two: one for the oxygen cylinder and one for the acetylene cylinder. Each regulator has a threaded nipple so that it can be attached to the top of the cylinder, and a threaded connection so that it can be attached to the hose line that leads to the torch. A hand operated turn-screw on each regulator adjusts the pressure as required to obtain the proper flame for the work at hand. This regulation of the flame will be detailed later on. Regulators are included in the complete equipment kits available in local welding supply shops and can be purchased at Sears or Montgomery Ward catalog and retail stores.

6

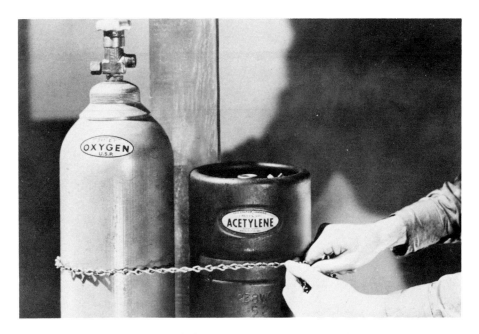

Fig. 2. Oxygen and acetylene cylinders.
Courtesy of Union Carbide Corporation, Linde Division

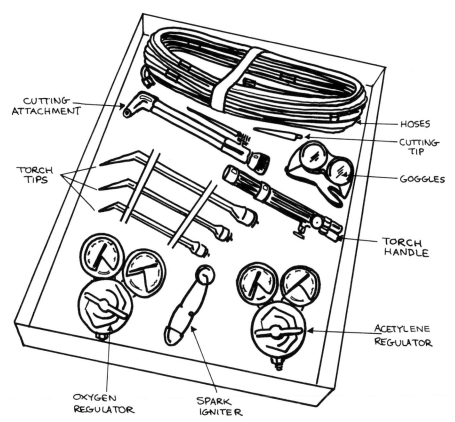

Fig. 3. Equipment needed to accompany cylinders of oxygen and acetylene.

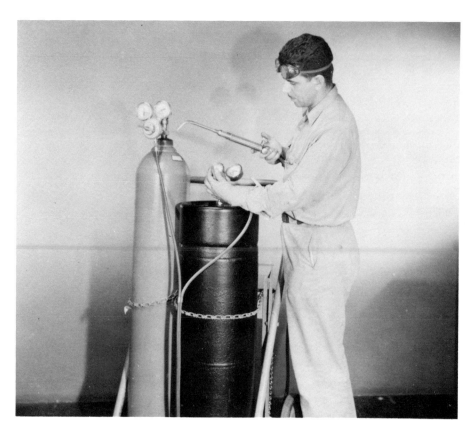

Fig. 4. Complete oxygen and acetylene systems.
Courtesy of Union Carbide Corporation, Linde Division

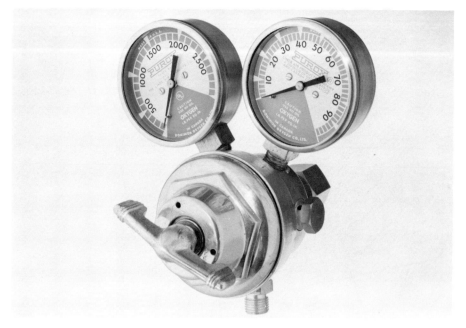

Fig. 5. Oxygen regulator.
Courtesy of Union Carbide Corporation, Linde Division

OXYGEN REGULATOR

Your oxygen regulator will be similar to the one shown here (see Fig. 5). It must be affixed to the green cylinder and connected to the green hose which leads to the torch. Figure 6 shows an oxygen regulator being connected to an oxygen cylinder. A regulator wrench is being used to tighten the union nut between the regulator and the cylinder valve.

The dial on the left indicates the quantity of gas in the oxygen tank.

The dial on the right indicates the amount of oxygen pressure flowing into the torch. This amount is adjusted by the turn-screw on the base of the regulator.

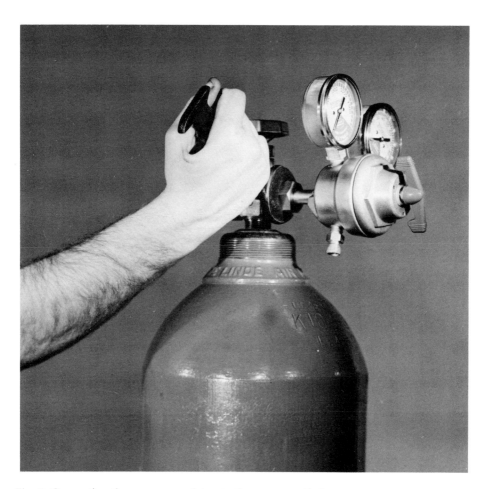

Fig. 6. Connecting the oxygen regulator to the oxygen cylinder.
Courtesy of Union Carbide Corporation, Linde Division

9

ACETYLENE REGULATOR

A regulator similar to that shown here will be the acetylene regulator (see Fig. 7). It must be affixed to the blank cylinder and the red hose leading to the torch.

The dial on the left indicates the amount of acetylene in the cylinder.

The dial on the right indicates the amount of acetylene pressure flowing into the torch, where it will be mixed with oxygen. This amount is adjusted by the turn-screw on the base of the regulator.

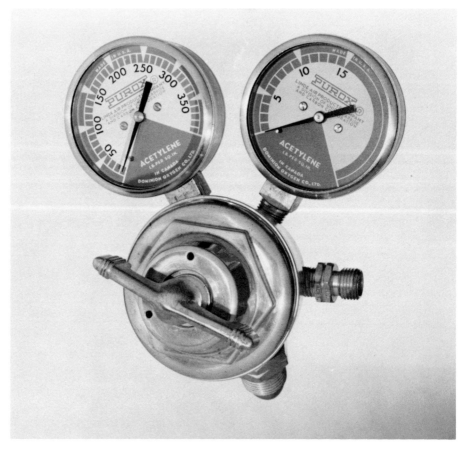

Fig. 7. Acetylene regulator.
Courtesy of Union Carbide Corporation, Linde Division

10

Safety

Safety is a primary consideration in dealing with any flammable material, but especially with those as combustible as oxygen and acetylene. When ignited, oxygen and acetylene produce what some call the hottest flame on earth. Therefore, precautions must be taken. The instruction booklet which comes with the equipment kit should be carefully studied and always followed.

Don't be frightened by the statement that great caution must be exercised in the use of your welding equipment. With reasonable care in handling there is no more danger involved than in using gas ovens or heaters. There is no need to be afraid.

The cylinders containing your oxygen and acetylene are very strong and unless they are carelessly handled there is little or no chance of their exploding. The possibility of leakage must be checked occasionally and, if found, must be dealt with promptly. The checking process is simple and the cure rudimentary. The method of checking will be explained as we go on to describe the setting up of your work area.

It is obvious that other flammable materials should not be kept in close proximity to the welding equipment. The more fireproof the work area can be made, the less you will have to concern yourself with the few dangerous aspects of the work. Bear in mind that when you have followed the precautions time after time they become habit and will cease to unduly concern you.

Operating the Welding Apparatus

OPENING THE VALVES

The first step in welding is to open the valves on the cylinders. Stand to one side of the gauges, *not in front of them,* as you open the valves.

Begin with the oxygen tank by slowly turning the wheel of the valve (see Fig. 8). Remember, there is great pressure in the cylinder and if you turn the wheel too quickly the sudden rush of oxygen pressure may damage the regulator. Turn the wheel only enough to allow the hand of the pressure indicator on the left to climb slowly to the point that indicates the cylinder contents. Then open the wheel about one full turn further.

Now, using the T-handle wrench slowly open the valve on the acetylene cylinder. When the pressure gauge hand stops give the T-handle one more full turn. The cylinders are now ready to supply the torch.

Next, adjust the turn-screw on the regulators to obtain the desired pressure to be fed to the torch for your special welding purposes.

For light steel welding, set the pressure by slowly opening the turn-screw on both the acetylene and the oxygen cylinders until the gauge hands register 5. At this point, the torch valves are still closed.

Caution: Do not use pliers or a monkey wrench to tighten or loosen the regulator connections. The metal of these parts is soft and the repeated use of the wrong tool will soon bend them out of shape so badly that even the proper tool will no longer work. Special regulator wrenches are available at the place where you buy your welding kit.

You will use a T-handle wrench to open the valve on the acetylene cylinder. Figure 9 shows this wrench in the proper position. Open the valve slowly and do not stand directly in front of the regulators while you are opening it. Although I have never heard of an accident caused by too abrupt a release of pressure from the cylinders, it is just as well to be careful and stand to one side. The left-hand dial will now indicate the amount of acetylene gas available.

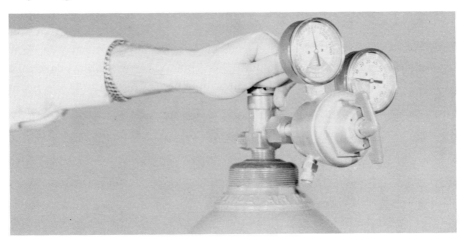

Fig. 8. Opening the valve on the oxygen cylinder.
Courtesy of Union Carbide Corporation, Linde Division

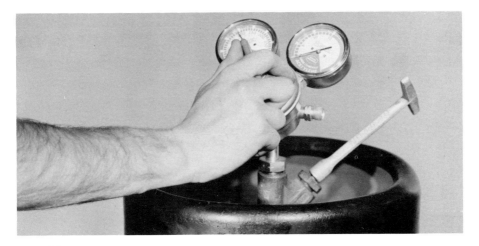

Fig. 9. Turning the screw handle on the acetylene regulator to release the flow of gas to the torch-tip.
Courtesy of Union Carbide Corporation, Linde Division

13

In Figure 9, the hand is engaged in turning the screw handle on the acetylene regulator. The turning of this handle will release the flow of gas to the torch-tip. For most welding purposes the indicator on the right-hand dial should register about five pounds.

A pressure of about five pounds will also suffice for the oxygen tank (right-hand indicator) unless it is necessary to cut heavy steel, or a particularly hot flame is needed for a heavy weld.

You will find that the oxygen cylinder is used up much faster than the acetylene cylinder. After a bit of experience you will become acquainted with the approximate working time each full cylinder of oxygen and acetylene will furnish you and you will be able to gauge when to place refill orders with your supplier so that you won't be caught without gas in the middle of working on a sculpture.

TESTING FOR LEAKS

Every few days test the hose, torch and cylinder connections for leaks. Continued use may cause the various connections to loosen. If the leak is a small one, detection by smelling or hearing the escaping gases may not be possible.

There is a simple, sure way of testing for leaks. Dissolve a piece of soap in a small quantity of water. (This liquid soap may be kept in a covered jar for regular use.) Now take a small brush and dab the soapy water over the various connections and valves of your cylinder system. You should check each of the seven places indicated in Figure 10 for possible leakage. The soapy water will bubble at a point of leakage no matter how small the leak may be.

Do not hunt for a leak with a match!

Should a leak be discovered, use the special wrench to tighten the connections. If the leak persists have the equipment checked by the supplier.

IGNITING THE TORCH

Because there are several models of welding equipment there may be slight variations in the lighting procedure. Therefore you should study and follow the special directions that come with your equipment.

There are two valves on the torch. The one connected to the red hose is for acetylene and the one connected to the green hose is for oxygen.

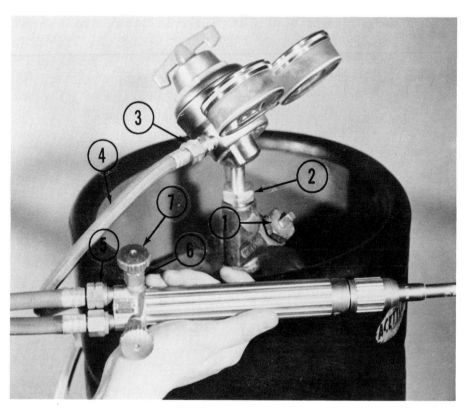

Fig. 10. Places on the cylinder systems to be tested for leakage.
Courtesy of Union Carbide Corporation, Linde Division

Fig. 11. Using the friction lighter to ignite the torch.
Courtesy of Union Carbide Corporation, Linde Division

The lighting procedure you use will be similar to the procedure described here. First, open the acetylene valve (red hose) about half a turn. Then with a spark from the friction lighter (see Fig. 11) ignite the acetylene issuing from the torch. The flame will be orange and with the proper valve opening it will smoke slightly. Now open the oxygen valve (green hose) with half a turn. The oxygen is now mixing with the acetylene and the flame will be blue.

Note: After the torch is ignited all of the subsequent adjustments you make will involve only the two valves on the torch.

THE FLAME

The area of the flame most used in welding and minor cutting processes is called the neutral flame (see Fig. 12). The neutral flame is the white, inner cone at the tip of the torch where the acetylene and oxygen are issuing in equal parts. The white neutral flame cone is surrounded by a blue flame area which is the result of air mixing with the oxygen and acetylene.

When more acetylene is added to the mixture (by turning the acetylene control valve on the torch) a third area of flame appears between the white, inner cone of flame and the blue, outside envelope of flame (see Fig. 13). This part of the flame, the acetylene feather, is used for lesser applications of heat.

When more oxygen than acetylene is added to the mixture, the two basic white and blue flame areas remain, but the white inner cone is shortened and now has a purplish tinge. This oxidizing flame is hotter than the excess acetylene flame (see Fig. 14). It is used, in an operation called brazing, for joining a variety of bronzes and brass.

Familiarity with the special uses of the various flames will be acquired through practice. Exact formulas cannot be given because the flame intensities vary with the size of the torch tip, the length of time the torch is applied to the weld and the thickness and nature of the metal being welded.

SHUTTING OFF THE APPARATUS

It is extremely important for you to make sure that your cylinder systems are safely shut off when your welding day is done. Thus, the steps described below and indicated in Figure 15 should always be carefully followed.

1. Close the wheel at the top of the oxygen cylinder.
2. Open the oxygen valve on the torch until the oxygen regulator indicates that the pressure is down to zero.

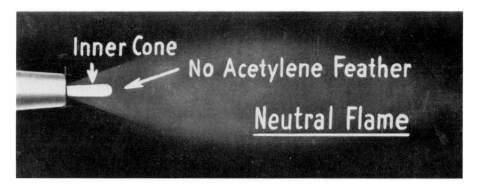

Fig. 12. The neutral flame.
Courtesy of Union Carbide Corporation, Linde Division

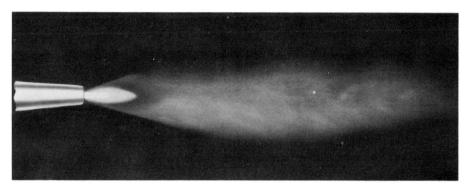

Fig. 13. The flame created by using more acetylene than oxygen. Note the acetylene feather between the white inner core and the outer blue envelope of flame.

Fig. 14. The smaller and hotter flame created by using more oxygen than acetylene. Note that there are only two flame areas—the white inner core (now shortened) and the outer blue envelope of flame.
Courtesy of Union Carbide Corporation, Linde Division

17

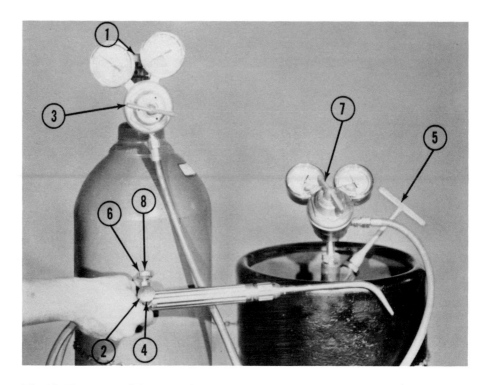

Fig. 15. The steps to follow to safely shut off your welding apparatus.
Courtesy of Union Carbide Corporation, Linde Division

3. Open the turn-screw on the oxygen regulator completely.
4. Close the oxygen valve on the torch.
5. Close the acetylene cylinder valve with the T-handle wrench.
6. Open the acetylene valve on the torch until the acetylene regulator indicates that the pressure is down to zero.
7. Open the turn-screw on the acetylene regulator completely.
8. Close the acetylene valve on the torch.

BACKFIRE

The beginning welder is sometimes frightened by a popping noise or a loud bang similar to the sound of a car backfiring. The torch flame will often go out at the same time. This is usually caused by holding the flame too close to the metal being welded.

Don't let such noises frighten you. Just follow the directions to relight your torch and then work a few inches farther away from the metal.

Twisted Wire Sculptures

Although the welding process is the best and most permanent method of making "line drawings" in steel, it is convenient (and usually a good idea) to make practice wire "sketches" as preliminary steps. Sketching sculpture in pure line with wire will provide a three-dimensional guide to the ultimate welded metal sculpture. Figures 16A, B and C are examples of twisted wire sculpture (Figure 16C also appears in the color section).

Pliable wire (even the ubiquitous wire hanger) is an excellent drawing material. It can usually be bent with the hands or, if necessary, pliers can be used as a shaping tool. A wire cutter and perhaps a vise are the only other things you need.

Fig. 16A. A wire "sketch" of a horse.

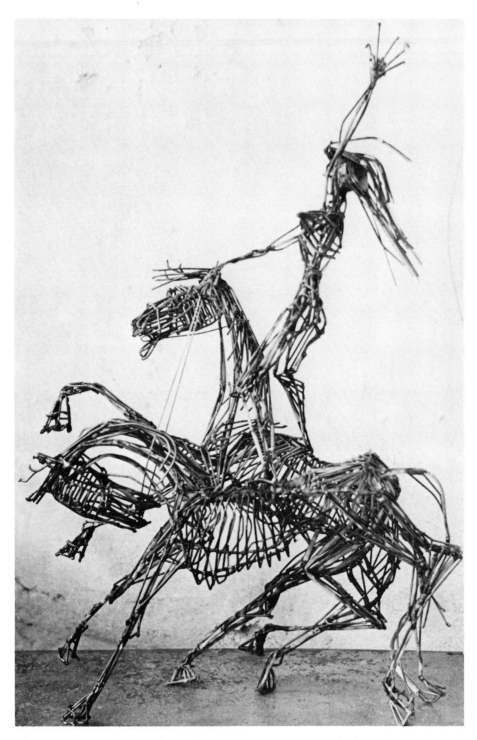

Fig. 16B. *Circus Rider*, a twisted wire sculpture by the author.

21

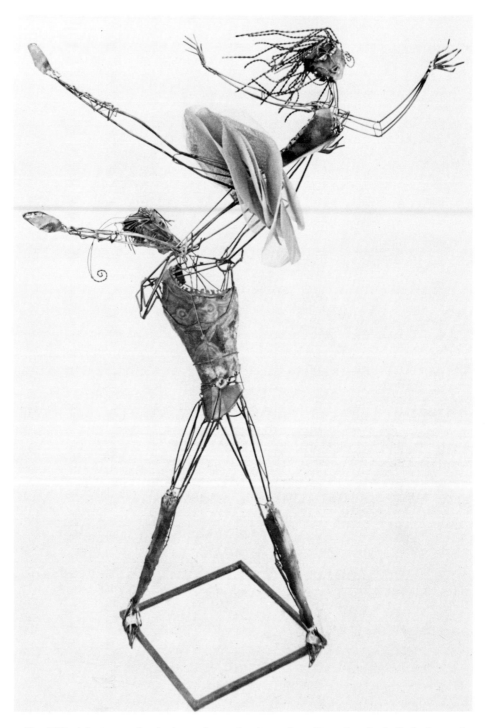

Fig. 16C. *Adagio*, a twisted wire sculpture by the author. Note that the ballerina's tutu is made of screening material. *Photo by Anne Caffrey*

Soldering

Solder may be used in the construction of metal sculptures to join pieces of wire or metal. The strength of a soldered joint is never anywhere near that of a welded joint, but it is adequate for small, lightweight pieces.

You will need the following equipment to solder:

1. An electric soldering tool
2. Spools of solder
3. Solder flux

Solders are available in various thicknesses. Your choice should be guided by the size of the sculpture you are undertaking.

Flux is a necessary ingredient for making the solder stick to other metal surfaces. If the solder does not already contain flux it must be manually applied or the solder will not adhere to the metal surfaces. All you have to do is briefly heat the solder wire in a gas candle flame and then dip it into the can of flux or liquid paste before the soldering iron is applied to melt and fuse it.

DRIP SOLDERING

Drip soldering can produce some fascinating textural qualities (see Fig. 17) as well as work which is more permanent than twisted wire sculpture. Metal solder drippings are applied to an armature of wire that has been covered with a light mesh wire screen that receives and holds the drips of solder.

23

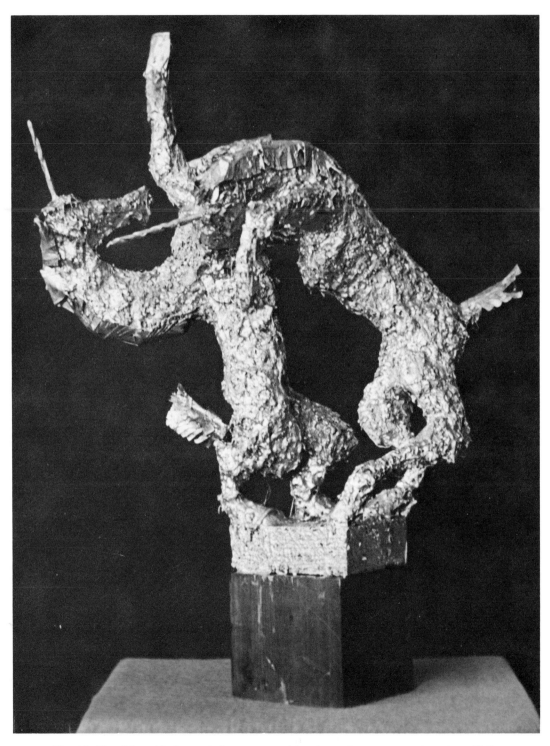

Fig. 17. The drip soldering technique was used by the author to create these beautifully textured *Fighting Unicorns*.

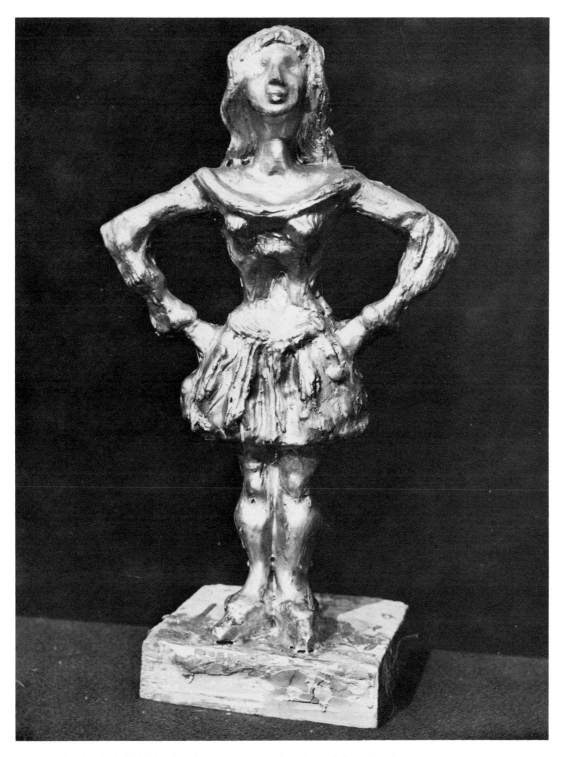

Fig. 18. This ballerina has been covered with a flow of liquid solder.

The armature acts as a rough, skeletal support for the dripped solder. It must be made of wire strong enough to support the solder's weight and light enough to be bent, by hand or with pliers, to the required shape.

When you have the shape you want, cover the armature with wire screen. Now hold a solder wire a few inches above the screen and apply a hot, electric soldering iron to it. The drips of molten solder form a metal "skin" which covers the entire surface of the screen and makes a strong permanent piece of sculpture.

LIQUID SOLDER

Liquid solder can also be used to obtain interesting and unusual textures (see Fig. 18). It is a prepared commercial product packaged in tubes and available in most hardware stores. When the liquid solder has set it becomes quite hard and may be considered a valid material for use in the creation of permanent metal sculptures.

Welding Techniques and Materials

TECHNIQUES

A piano teacher can only teach the student how to read music, the meaning of the chords and the way to hold the hands in striking the piano keys. Beyond these aids and a few similar simple studies the student must seek concepts and a style of his own. In the same way, the teacher of welded sculpture can only give the student the rudiments of equipment handling, instructions in safety regulations and a few suggestions of where and how to begin.

But you will soon develop a comfortable familiarity with the tools, the hot flame will no longer be terrifying and the steel will become "putty in your hands." Beyond that point your special vision, personal taste and individual style will take over and begin to develop.

Study the styles and techniques of the various welder-sculptors whose work is reproduced in this book. Go to art museums and study in detail the wide variety of welded sculptures. Visit the library and pore over books which contain pictures of sculpture. Borrow the technical information and styles that strike you as being pertinent to your own viewpoint of sculpture.

Once you have a vista of the welded sculpture created by others, launch your own creative fancy and say what you have to say, in your own way, vividly and precisely through your knowledge of how to use your tools.

MATERIALS

WELDING RODS

Most of the linear sculptures shown in the following pages were made with steel welding rods (see Fig. 19). These rods are formed by "hot-rolling," a process which produces a soft, easily melted steel. They serve a dual purpose. Welding rods are used by commercial welders to fortify and help to fuse the joining of two pieces of hard steel or iron because in the process of flame-fusing some metal is lost. The addition of welding rod steel, melted into the joint, replaces the lost metal. The sculptor-welder may use welding rods for this purpose and also for the actual construction of pieces of sculpture.

Steel welding rods are readily available at welding supply shops in bundles of three-foot lengths ranging from the thickness of very slim wire to a diameter of one-quarter inch. Welding rods made of bronze, brass and silver are also available. These rods are used for special purposes which will be detailed later on.

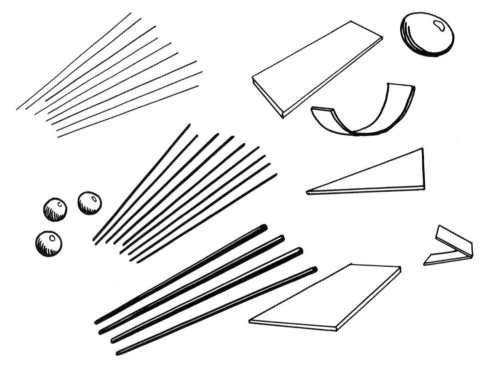

Fig. 19. Welding rods and other metal welding materials.

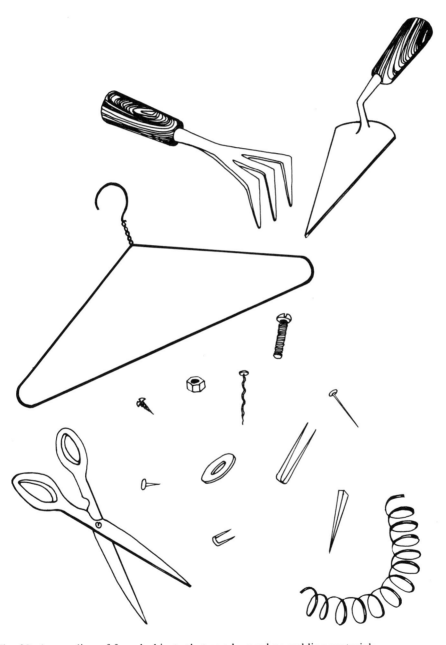

Fig. 20. A sampling of found objects that can be used as welding materials.

FOUND OBJECTS

The welder-sculptor must always keep his eyes open and his imagination alert for iron or steel objects which could be used in his sculpture (see Fig. 20). The inherent shape of each such object suggests its use in some special part of a sculpture and may even suggest a theme to the sculptor. Cut nails, sometimes called floor nails, make excellent fingers. Entire small figures can even be made using nothing but these relatively soft, easily fused nails. These and virtually all other types of nails should be considered as welding materials. Staples and screws also add their own special virtues to the stock of the imaginative welder. Wire coat hangers make good, pliable welding wire and are an inexpensive source of supply.

Search junk yards and dumps for discarded garden tools—trowels, hoes, rake heads and so on—to make claws, teeth, ribs and various other animal or human anatomical parts. With a developing sense of opportunities, the imaginative artist-welder soon finds possibilities in a pair of old dull scissors or a pair of pliers—they are almost the legs and torso of a figure already! Coiling springs make hair, pliant spines or whatever else your fancy may decide.

Allow your imagination and wit full rein. Embrace the habit of collecting all the bits of metal junk that our wasteful, throw-away economy places in your path. You will be helping to remove pollution from our landscape and you will have the added bonus of making it into beautiful objects.

STEEL PLATES

Sculptured steel drawings may be shaded just as penciled drawings are shaded. Steel plates in certain areas of a sculpture will provide solid areas to contrast with the lines created by the use of welding rods (see Fig. 21).

Both light-gauge and heavy steel plates can be easily cut to shape. This cutting process will be detailed later on. Once the steel plates are cut, shaping and bending can be accomplished by heating them with the welding torch and then fusing them to the steel rods of the sculpture.

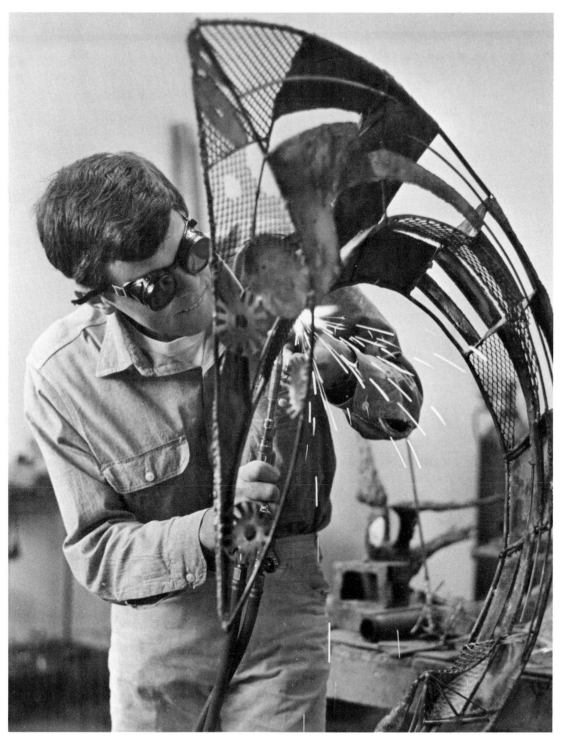

Fig. 21. A student using steel plates and large-mesh screen to create shading and give varying textures to his sculpture.

Courtesy of Instituto-Allende, San Miguel Allende, Mexico

Matchstick Figures

Considering the elaborate equipment involved in welding, to suggest that you do a series of matchstick figures as you did in your first childhood drawings would seem to be an affront to both you and your equipment. However, this basic approach to drawing in steel is most instructive and in addition will probably enable you to produce some delightful pieces right at the very outset.

The series of sketched figures illustrated here (see Figs. 22A, B and C) are shown in various positions using a minimum of lines—the matchstick state. These preliminary sketches serve both as the scaffolding upon which the ultimate figure is supported and as a guide to the basic stance and action of the figure as you continue to add detail in your progress toward the completion of your sculpture.

Some of the matchstick figures are also shown with metal rods superimposed upon the matchsticks (see Figs. 23 and 24). The original matchstick structure will show through all of the later stages of your sculpture, but that is desirable and will add to the dynamism and design of your finished piece. In order to clarify these "finished" drawings, the first state, or scaffolding, is usually only indicated on the preliminary sketch.

Simple drawings on paper, such as these, should be made before you begin to form a piece from the actual metal rod. These sketches will serve as a working drawing similar to the plans which carpenters and masons use in building houses. The final result (see Fig. 25) will be assured of basic

strength and proper proportions if you have the guidance of a carefully drawn working plan.

During the actual welding of the rod figure you may decide to make simple changes in details or drastic changes in things such as the pose or proportions. Such changes are easily accomplished by manipulating the metal rod, utilizing the marvelous freedom given by the heat of the torch.

Fig. 22A. Preliminary sketches of matchstick figures.

Fig. 22B.

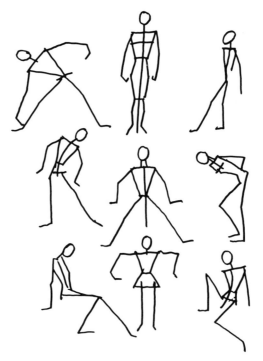

34

Fig. 22C.

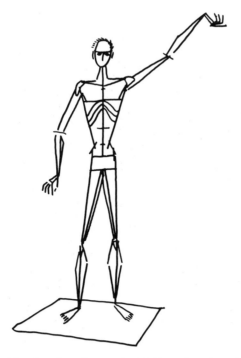

Fig. 23. A detailed working drawing of a matchstick figure based on the sketch in Figure 22A.

Fig. 24. Detailed working drawings of matchstick figures based on the sketches in Figure 22C.

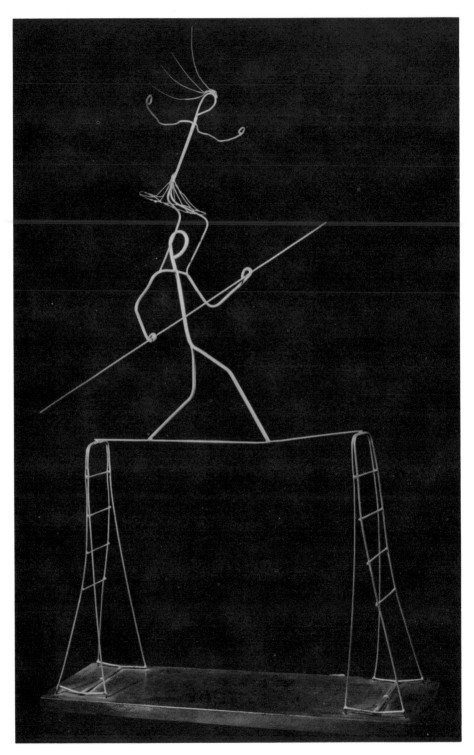

Fig. 25. *Wire Walkers,* a matchstick sculpture by Amy Small.
Photo by Jeremiah W. Russell

Heads

You construct a welded steel head by working in the same manner as you did with matchstick figures. You must first make a drawing and then create a base or armature upon which to build.

The head is, essentially, a flat oval when drawn, but in three-dimensional sculpture it will become egg-shaped (see Fig. 26). If you wish to create a more or less realistic head plan a scaffolding of metal rods bent and joined into an approximation of the skull. Upon that solidly build the outer surfaces of planes and contours using either slices of light-gauge metal or a close pattern of rods. These are only basic guidelines, for the imaginative welder may invent and stylize endlessly (see Figs. 27, 28 and 29, and color section). The medium of metal welding easily and admirably lends itself to a flexible, open approach.

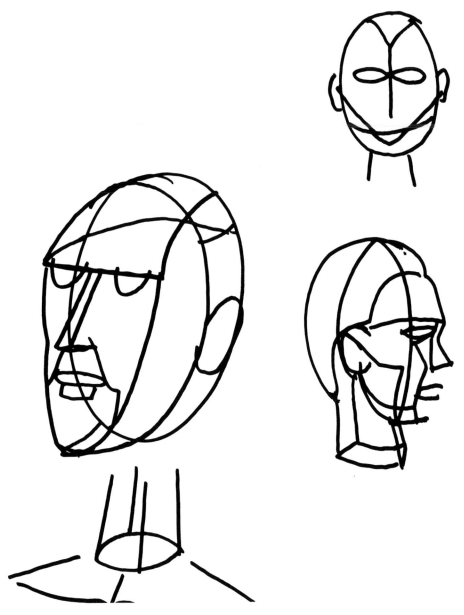

Fig. 26. Working drawings of heads.

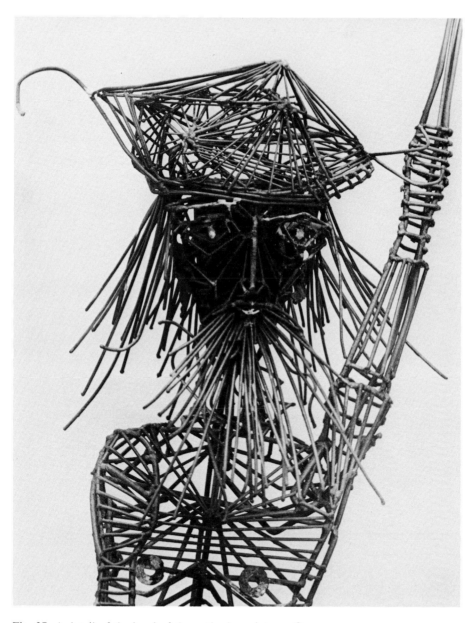

Fig. 27. A detail of the head of the author's sculpture, *Guru*.

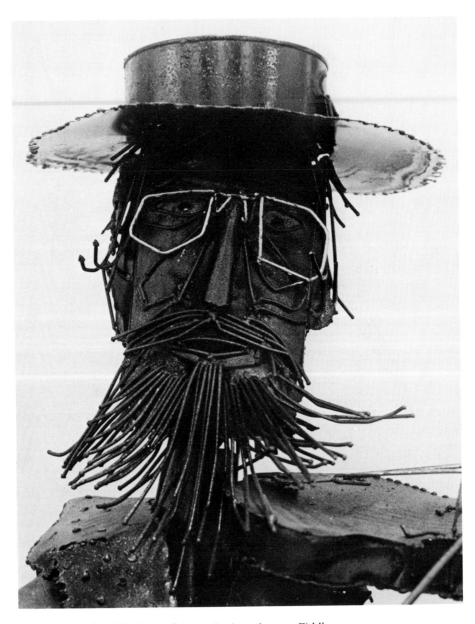

Fig. 28. A detail of the head of the author's sculpture, *Fiddler*.
Photo by Flores

40

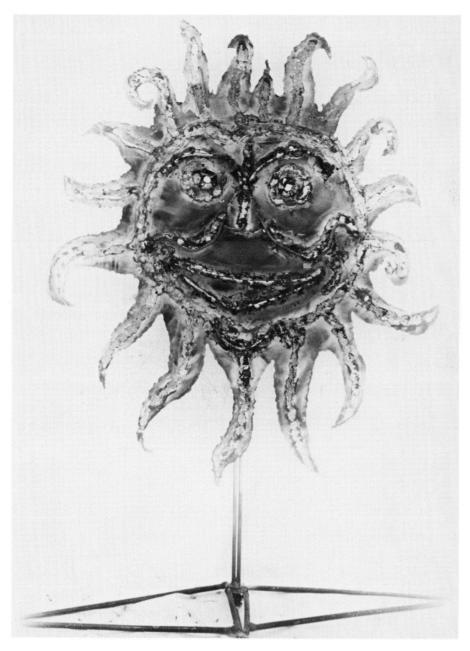

Fig. 29. An individual approach to a non-human head! *Face in the Sun* by the author.
Photo by Anne Caffrey

41

Bending Metal Rods

The oxyacetylene flame applied to a one-quarter or three-eighths inch thick welding rod will allow the sculptor to bend and shape it as though it were a thin wire being twisted by hand. For example, the hands illustrated in Figures 31 and 33 were modeled directly with the torch flame and a pair of pliers. They were drawn in steel.

With the ability to model strong steel to his will, the welder-sculptor has a unique opportunity to create almost any flight of his fancy directly in metal. This creative freedom is illustrated by the following series of working drawings and completed sculptures (see Figs. 30-66C and color section).

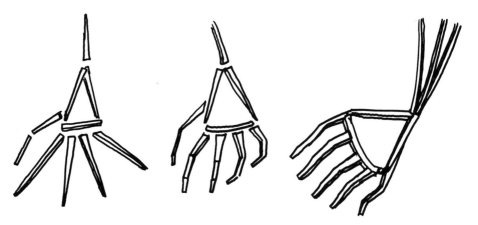

Fig. 30. Working drawings for hands.

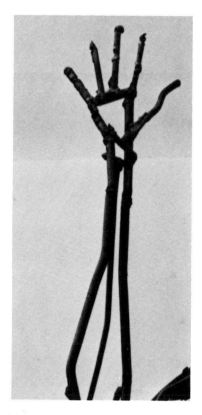

Fig. 31. A detail of a hand made from one-quarter inch welding rods.

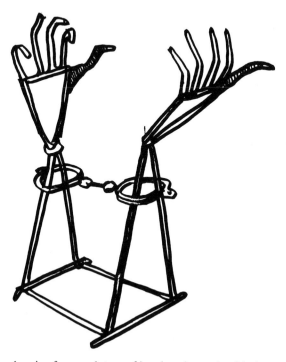

Fig. 32. A working drawing for a sculpture of hands to be made with three-eighths inch steel rods and toy handcuffs.

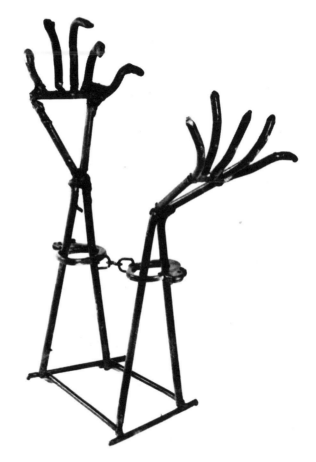

Fig. 33. The finished hands.
Photo by Robert Palmer

44

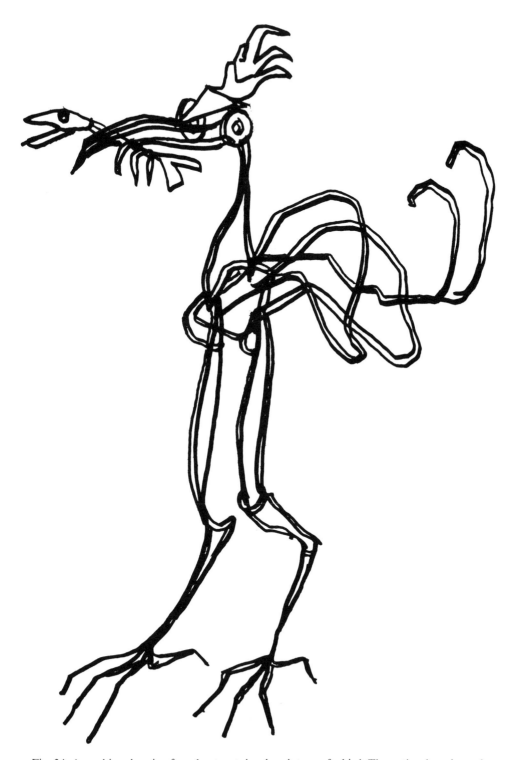

Fig. 34. A working drawing for a bent metal rod sculpture of a bird. The author has planned to use one-quarter inch rod along with found materials: a garden trowel for the bird's comb, large washers for his eyes, and tin cutters for the fish's head.

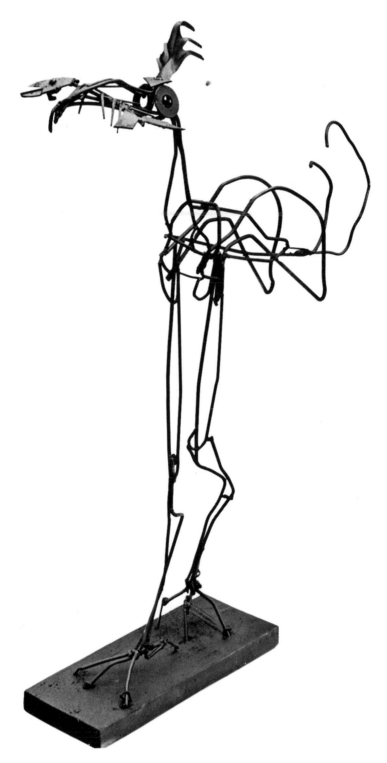

Fig. 35. The completed *Unclassified Bird* by the author.

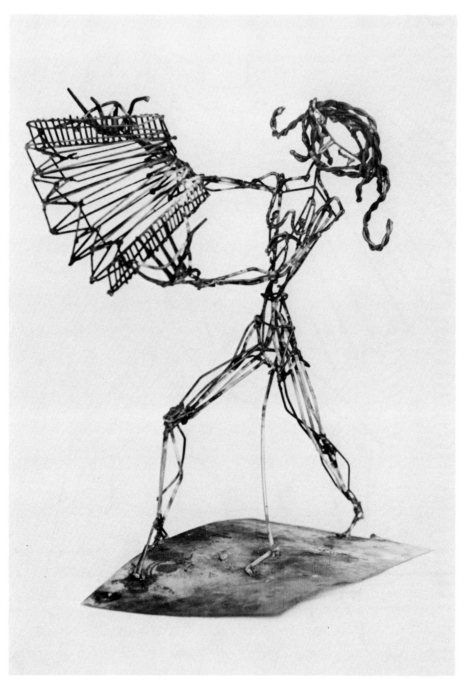

Fig. 36. *The Accordionist* by the author. This is a bent metal rod sculpture that began as a standing figure. Note the supporting rod that is welded to the temporary, working base.

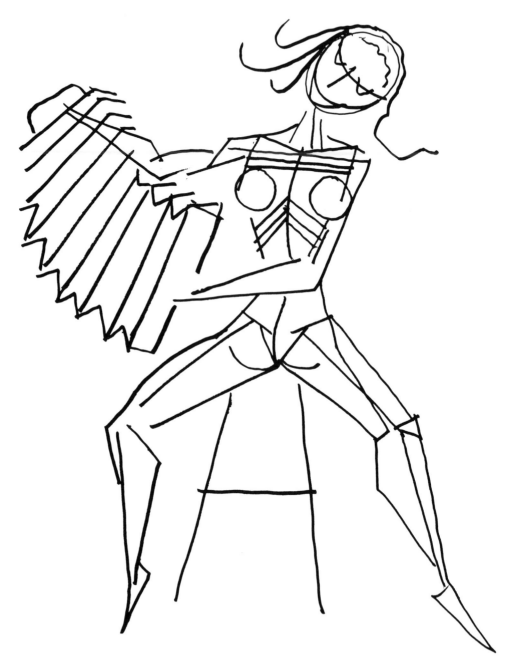

Fig. 37. Having decided to seat the accordionist, the author made this preliminary sketch. The fluid ease with which a sculptor-welder may change the design and stance of a figure in progress permitted this transformation from standing to sitting position.

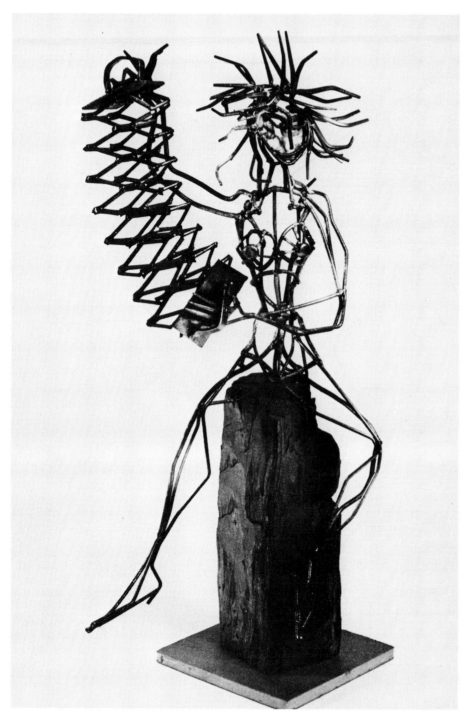

Fig. 38. The completed *Accordionist* in a sitting position. Note the three solid forms of steel that were used—the background for the features and the ends of the accordion. Except for these additions, the piece remained a line drawing in steel.
Photo by Robert Palmer

49

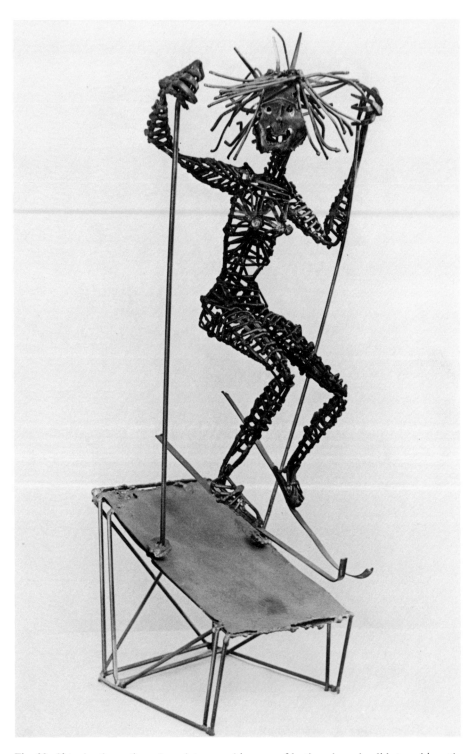

Fig. 39. *Skier* by the author. A sculpture making use of both rods and solids to achieve the desired representation.
Photo by Flores

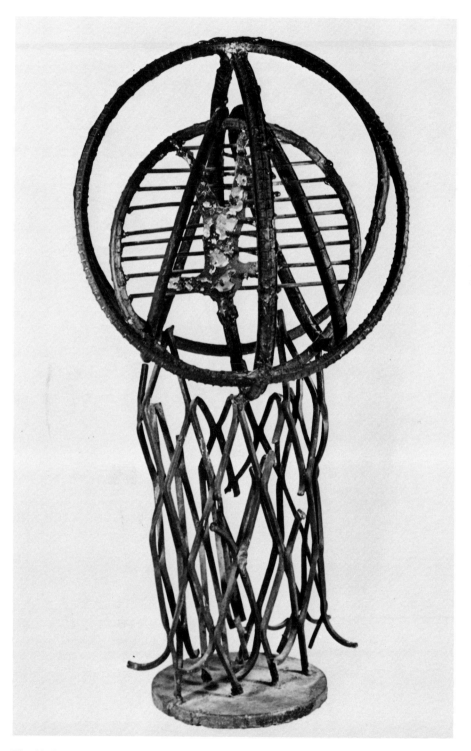

Fig. 40. Squared steel rods and concrete-reinforcing steel rods shaped into circles form this 24 inch high sculpture by James Pinto entitled *Rightsideup Man in the Upsidedown World.*

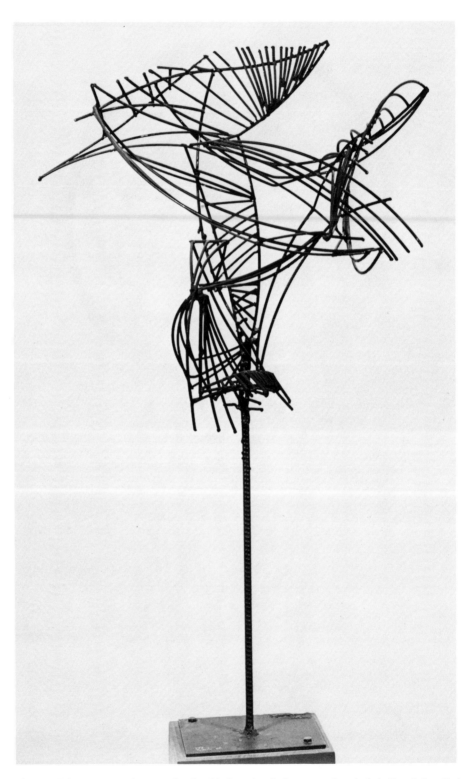

Fig. 41. This sculpture piece, made of welded steel rods, is executed entirely in line. It is called *Plant Form,* is 38 inches high and was created by James Pinto.

Fig. 42. A rough, preliminary working drawing for a sculpture of a goat.

Fig. 43. This simple line drawing in steel was made in an effort to capture the essential nature of a goat without the use of any extraneous details. *Goat* was created by the author.

Fig. 44. A rough, preliminary working drawing for a sculpture of a man on a horse.

Fig. 45. The work in progress. An effort is being made by the sculptor to retain the spontaneous character of the sketch.

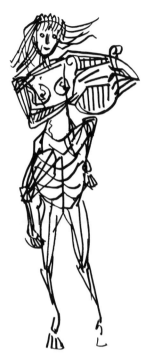

Fig. 46A. Preliminary working drawings for a centauress.

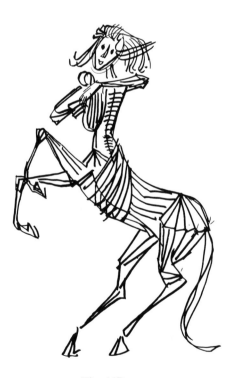

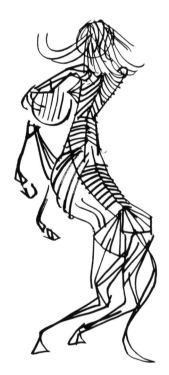

Fig. 46B. Fig. 46C.

56

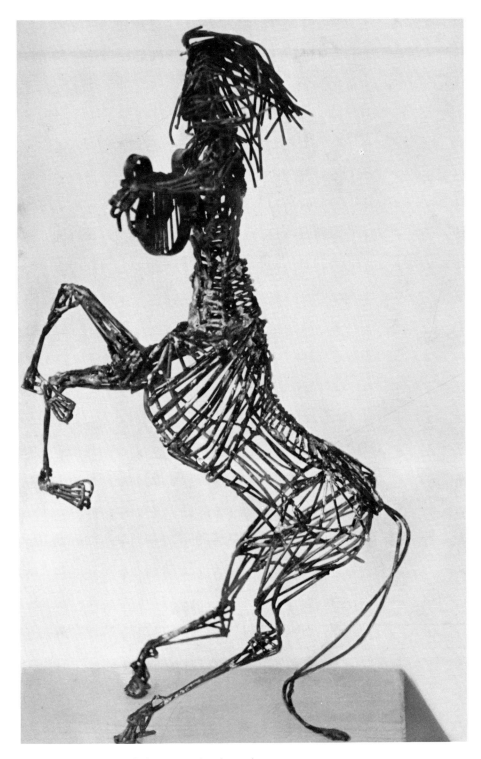

Fig. 47. The completed *Centauress* by the author.

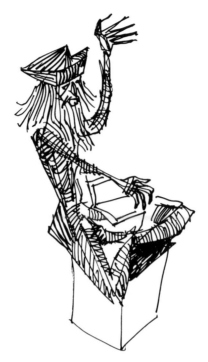

Fig. 48A. Preliminary working drawings for *Guru III*.

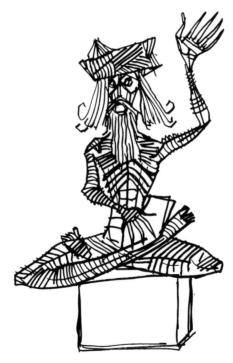

Fig. 48B.

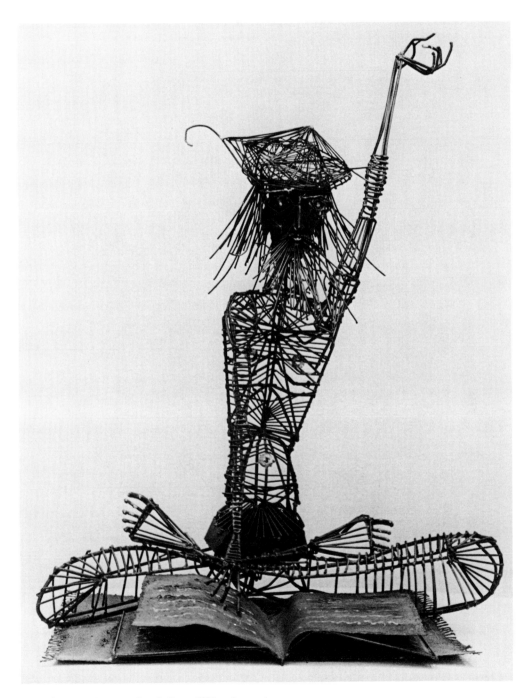

Fig. 49. The completed *Guru III* by the author.

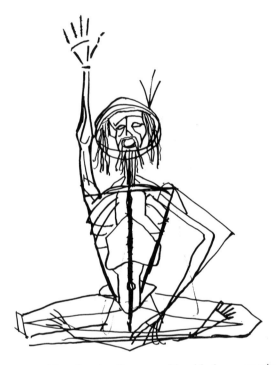

Fig. 50. A preliminary working drawing for a considerably larger version of *Guru III*.

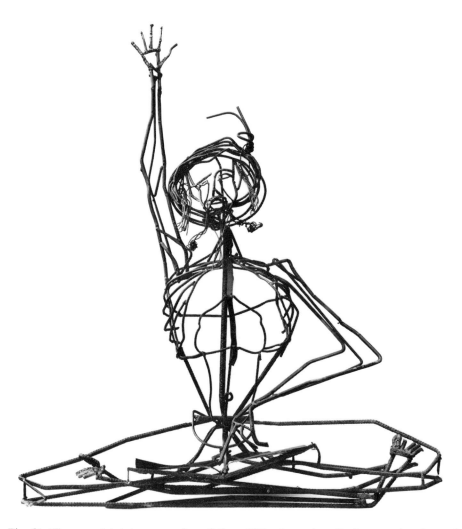

Fig. 51. The completed, larger version of *Guru III* by the author. Both squared and round steel rods ranging from one-quarter to one-half inch in diameter were used. Concrete-reinforcing rods work very well in large figures such as this.

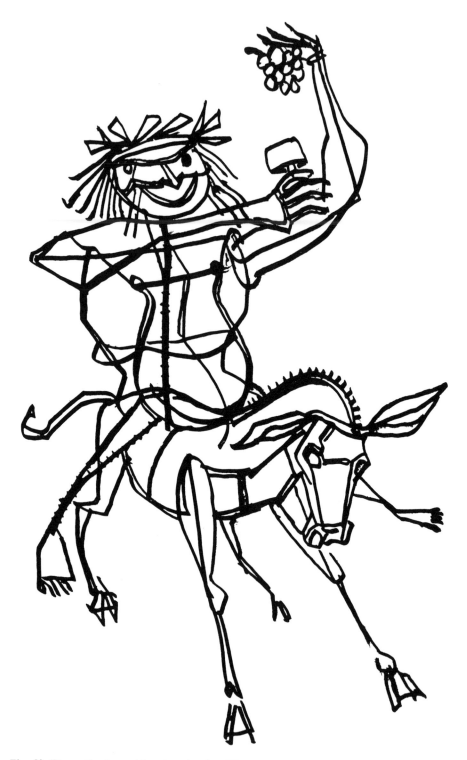

Fig. 52. The author's working drawing for *Silenus*.

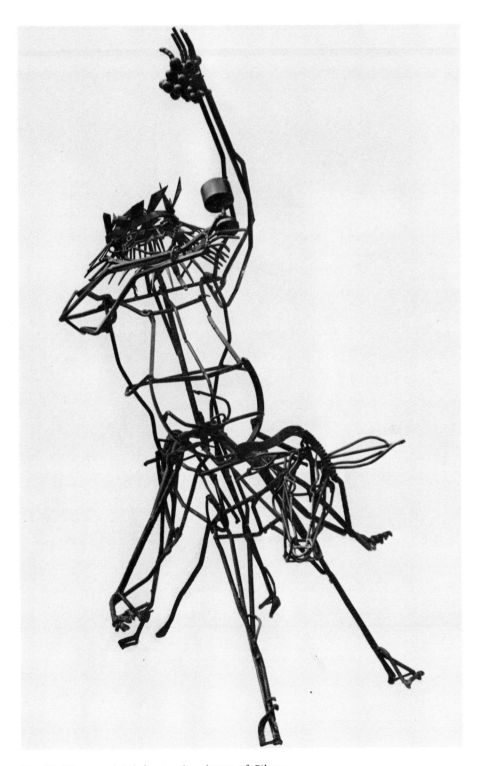

Fig. 53. The completed, bent rod sculpture of *Silenus*.

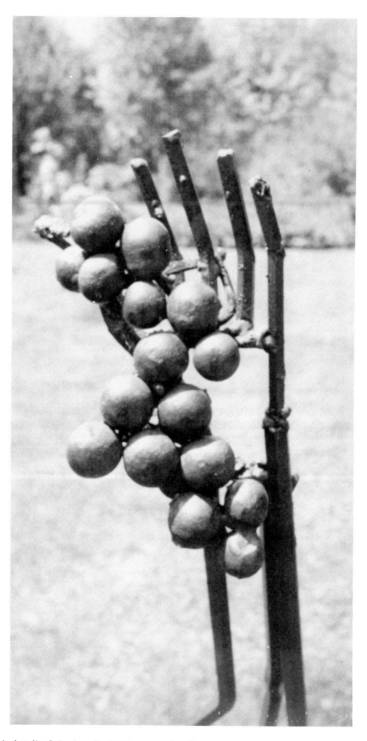

Fig. 54. A detail of the hand of *Silenus* made of one-quarter inch hot-rolled steel rod and a number of iron balls that were found in an ironmonger's junkyard.

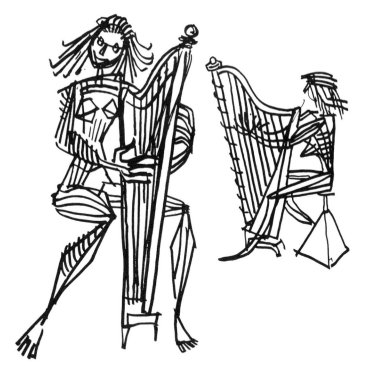

Fig. 55. Preliminary working drawings for a sculpture of a harpist.

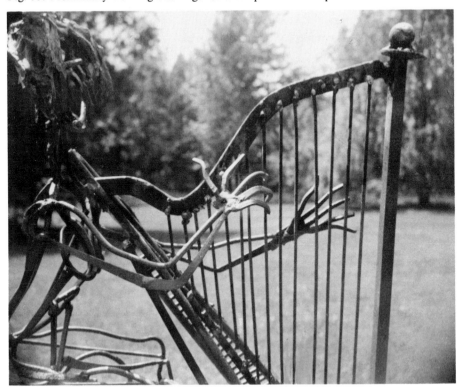

Fig: 56. This closeup of the author's completed *Harpist* demonstrates how careful bending of cut nails (floor nails) can express the sensitivity of fingers plucking the harp strings. The fingers were shaped by using the torch and a pair of long-nose pliers.

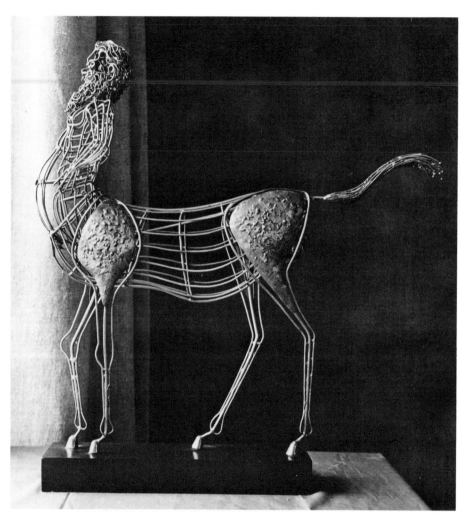

Fig. 57. *Centaur* by James Turnbull. Note the effective use of solids along with the rods.

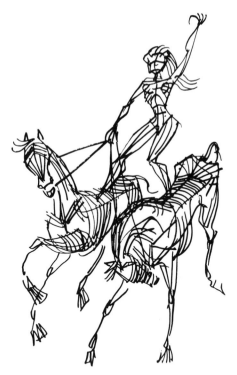

Fig. 58A. Preliminary working drawings for a sculpture of a woman astride two horses.

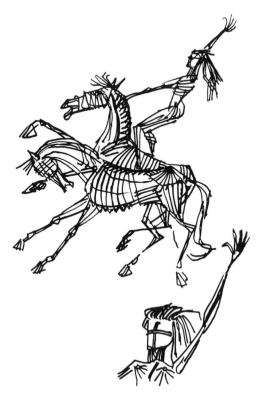

Fig. 58B.

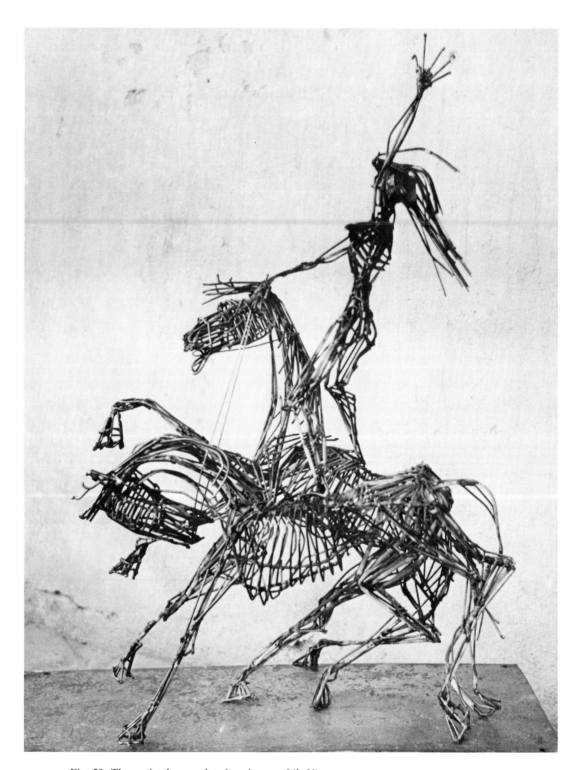

Fig. 59. The author's completed sculpture, *Lib Victory*.

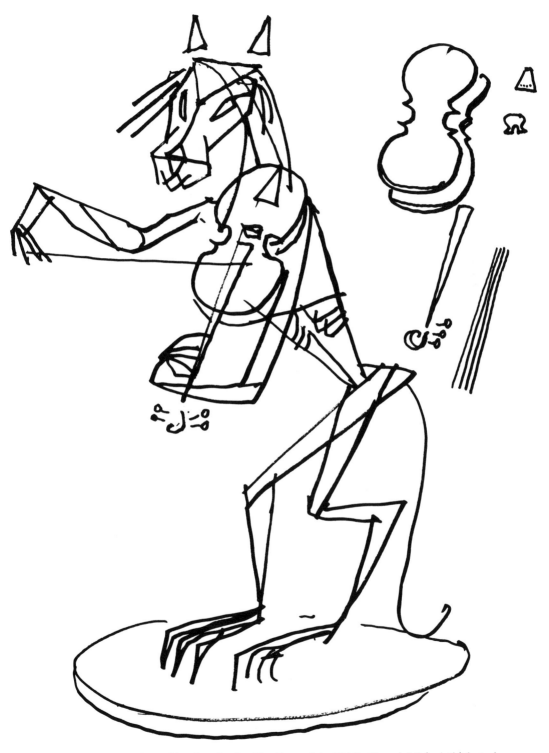

Fig. 60. The author's working drawing for *The Cat and the Fiddle*. One-eighth inch thick steel sheets are planned for all parts of the violin except the strings, which are to be made of very thin welding rods.

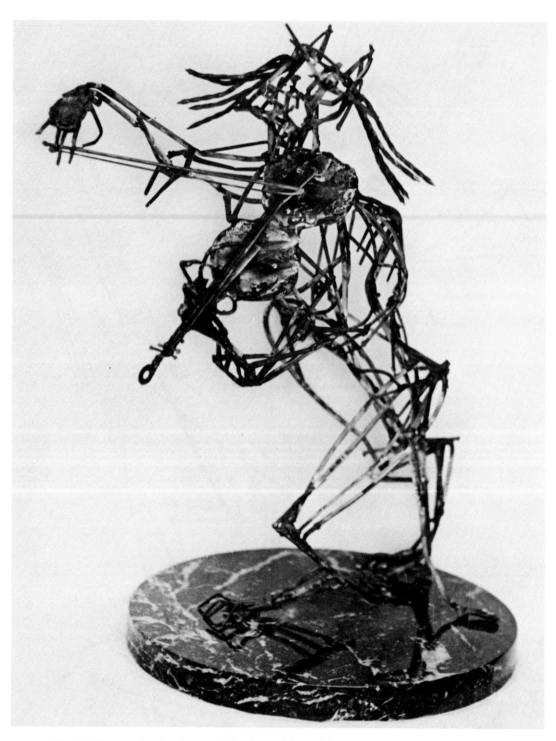

Fig. 61. The completed sculpture of *The Cat and the Fiddle.* Note the marble base upon which the sculpture has been mounted.

70

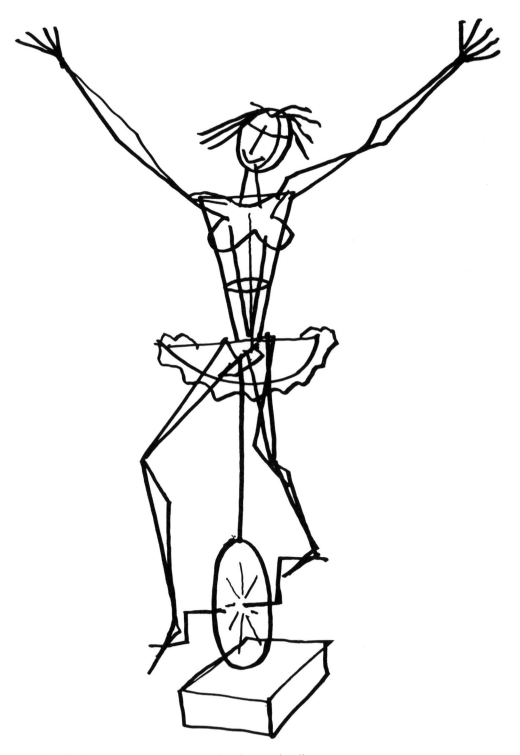

Fig. 62. The author's working drawing for a unicyclist.

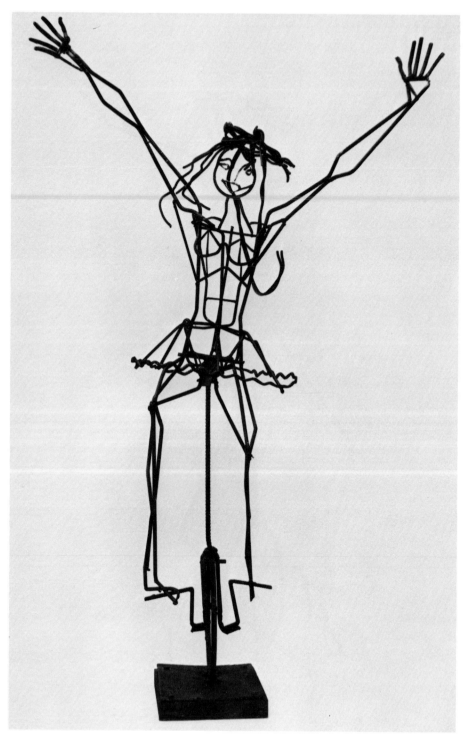

Fig. 63. The completed *Unicyclist*. This sculpture is 5 feet high and is balanced on one strong weld at the iron base.

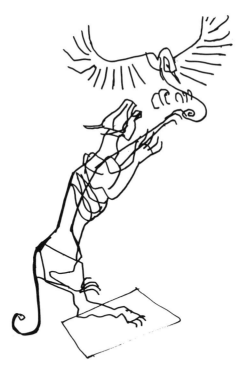

Fig. 64. The author's original idea for *Cat and Bird* represented in a working drawing.

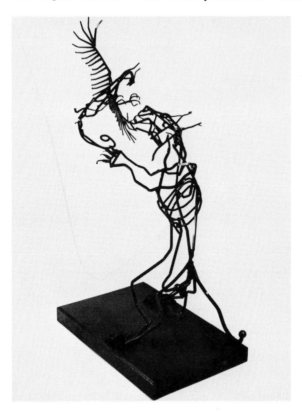

Fig. 65. The daring balance made possible by the strength of the steel rods allows the sculptor to create action even though the figure is poised on slim rods as in this *Cat and Bird*.
Photo by Robert Palmer

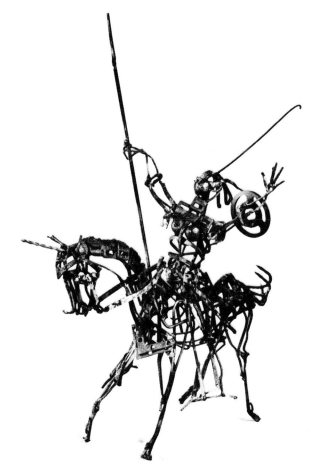

Fig. 66A. The use of a few solid-form odds and ends of small hardware give vitality to these three sculptures without detracting from their basic, flowing line character.
A. Photo by Robert Palmer

74

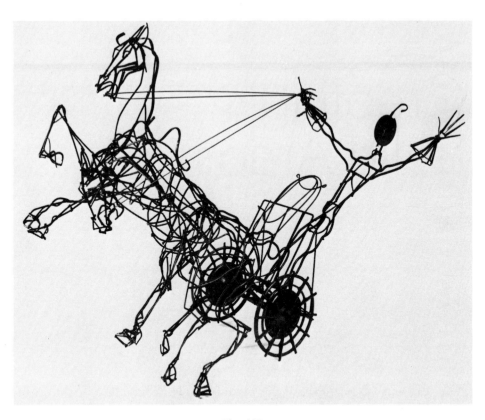

Fig. 66B.
B. Photo by Robert Palmer

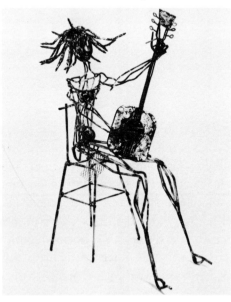

Fig. 66C.
C. Photo by Robert Palmer

Creating Solid Areas

Your drawings in steel have at this point been restricted mostly to the use of the "pure" line produced by the welding of steel rods and long nails. However, just as in penciled drawings your sculpted drawings may be shaded with areas of light-gauge plates of steel to provide a contrast between lines and solid planes. There are a number of methods which can be used to introduce solids.

SHEETS

Flat sheets of light-gauge steel may be cut to the shape required by using either a cutting tool or a torch. The flat metal can be bent into the convex or concave shape desired by fastening it in the vise and then bending it by hand or with pliers, or by heating the metal until it becomes pliable and then manipulating it with pliers. However, if the metal sheet is too light the ultimate effect will be tinny and the razor edges unpleasant.

A fairly heavy steel plate of, perhaps, one-sixteenth of an inch will give dignity and weight to your figures. Such sturdy metal must be cut either with heavy bench shears, with your welding torch or with the special cutter which is part of your welding kit. You will then use the welding torch to heat, shape and bend the steel plates you have cut to size, and to fuse them to the steel rods of your sculpture.

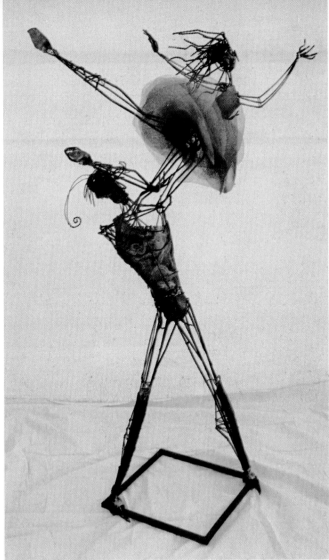

Adagio
Arthur Zaidenberg
Photo by Anne Caffrey

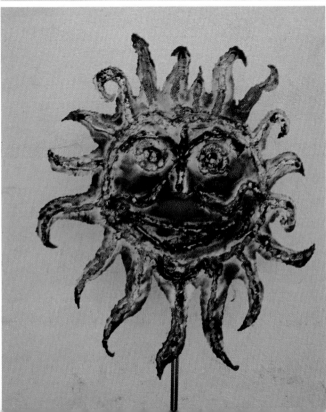

Face in the Sun
Arthur Zaidenberg
Photo by Anne Caffrey

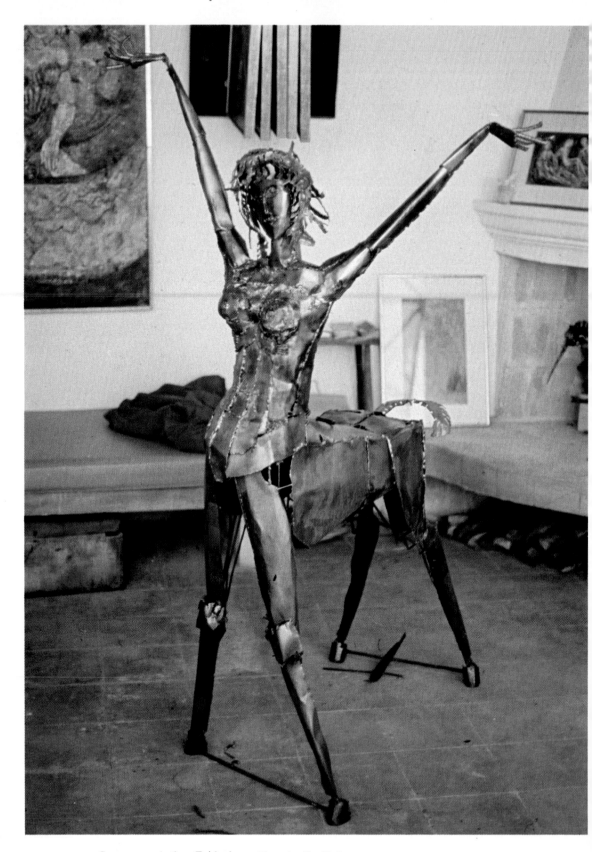

Centauress. Arthur Zaidenberg. *Photo by Hu Chain*

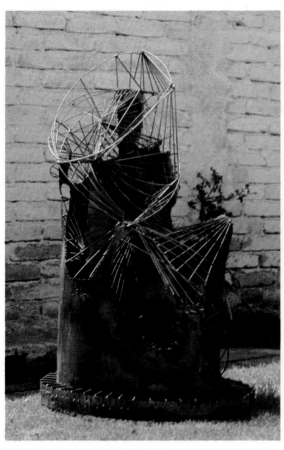

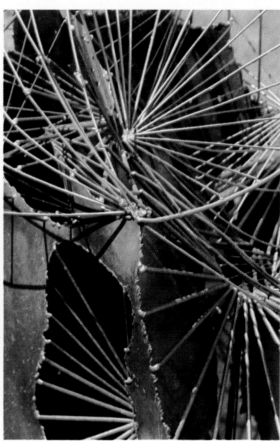

Kafka's Castle. Arthur Zaidenberg.
Photo by Alex Apostolides

A detail of *Kafka's Castle*
Photo by Alex Apostolides

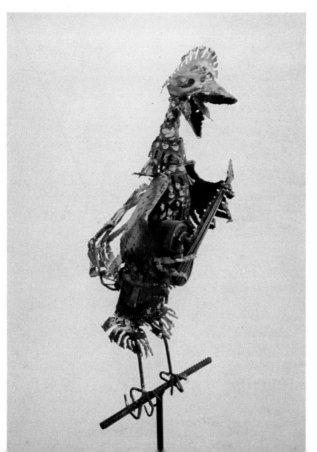

Musical Bird
Arthur Zaidenberg
Photo by Anne Caffrey

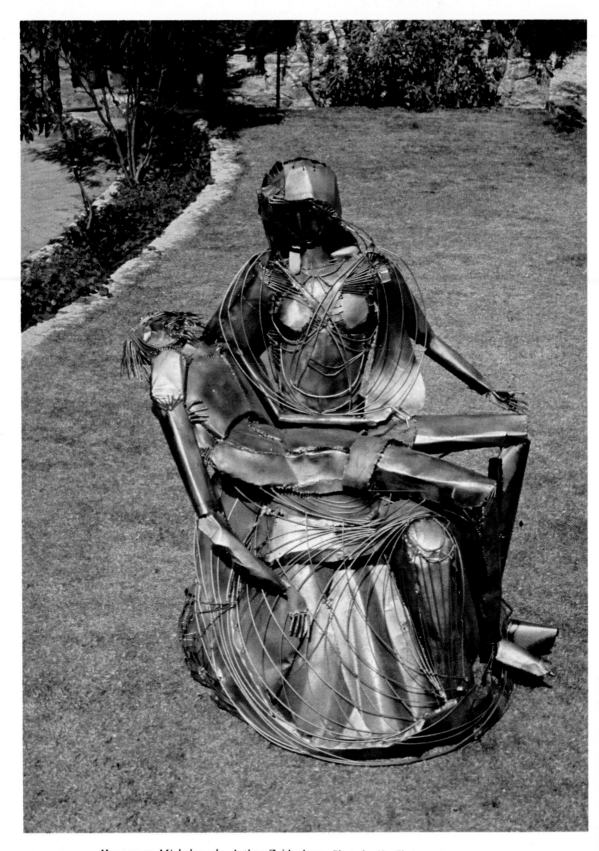

Homage to Michelangelo. Arthur Zaidenberg. *Photo by Hu Chain.*

RODS

Solid areas can also be achieved by welding-on short lengths of rods, side by side, and then applying the torch to fuse the adjoining rods lengthwise. Thus, one rough-surfaced piece of metal is formed. This operation is called puddling. Welder-sculptors frequently like to create a relatively solid plane by using these placed pieces of rod so that their juxtaposition will give the desired textural effect.

DRIPPINGS

Still another method of contriving a solid area is that of dripping molten globs of metal from a heated welding rod onto an area which first has been covered with a close-mesh wire screen. Pieces of steel window screen are perfect for this. If the dropped globs are close enough together to cover the screening completely, the resultant mottled surface will make a very effective solid area.

The Cutting Torch

You will frequently have occasion to cut through relatively thick pieces of metal for various purposes. If the metal you are going to cut is no more than one-eighth of an inch thick you can use the ordinary torch, but for thicknesses beyond that it is far more effective to use your cutting torch (see Fig. 67).

The cutting torch has two valves to regulate the quantities of acetylene and oxygen being fed to the preheating holes. A lever handle regulates a separate flow of pure oxygen which, when ignited, is the cutting flame.

Before you begin cutting check all safety factors. Be sure there are no combustible objects near your work area. Cutting creates a volume of sparks and sometimes bits of molten slag are thrown off by the metal being cut. Always wear your leather apron, your gloves and your safety goggles.

To practice cutting a straight line through a one-quarter inch piece of iron or steel, first rule a pencil or chalk line on the metal. Then fasten your cutting torch to the hose handle and open the acetylene and oxygen valves to the pressures required for cutting. These pressures are indicated in the instruction book that comes with your welding kit.

The four holes surrounding the tip of the cutting torch are the preheating source (see Fig. 68). The line to be cut is preheated to a cherry red by the mixture of acetylene and oxygen emitted from these holes. When the lever on the cutting torch is pressed the center hole emits a jet of oxygen. The intense heat of this jet, along with the mixed flames of acetylene and oxygen

78

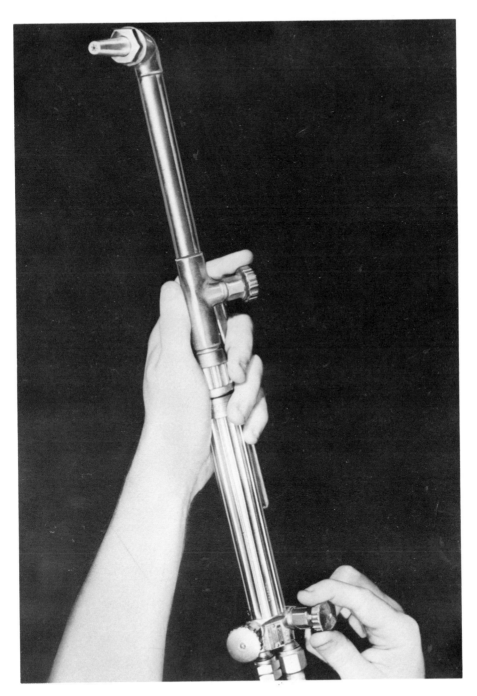

Fig. 67. The cutting torch.
Courtesy of Union Carbide Corporation, Linde Division

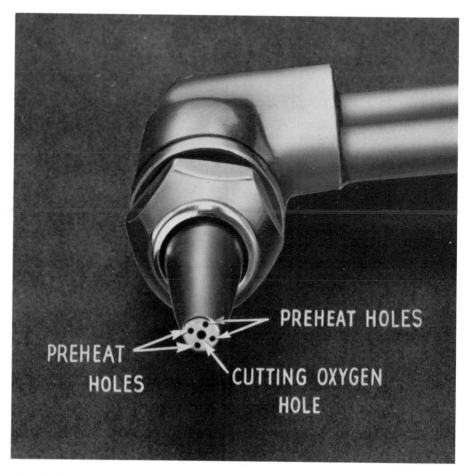

Fig. 68. The cutting tip.
Courtesy of Union Carbide Corporation, Linde Division

from the preheating holes, accomplishes the cutting. Hold the cutting torch so that when the lever is pressed the cutting jet of oxygen can immediately be brought into play.

Turn on the two levers at the base of the cutting handle. The mixture of oxygen and acetylene necessary to preheat the cutting line is now being emitted. Now ignite your cutting torch and hold the flame about one-eighth inch above the line you previously drew on the metal (see Fig. 69). Do not press the oxygen-mixing lever yet. Heat the line until it becomes cherry red. Now, starting at the edge of the plate, press the lever and the flame will begin to cut the metal (see Figs. 70, 71A and 71B). As sparks start to fly, move the flame slowly and steadily along the path of the ruled line. Be sure that the forward motion is uninterrupted and not so slow that the edges of the cut melt too much or the flowing metal fuses.

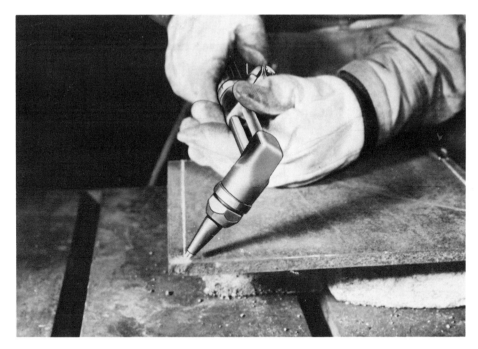

Fig. 69. Preheating the cutting line with the mixed oxygen and acetylene flames.
Courtesy of Union Carbide Corporation, Linde Division

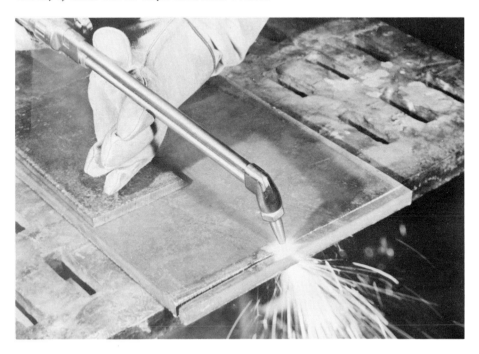

Fig. 70. Cutting the metal plate with the cutting jet of oxygen.
Courtesy of Union Carbide Corporation, Linde Division

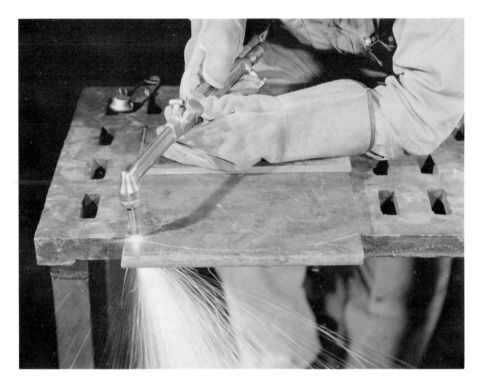

Fig. 71A. A carefully guided cutting torch being used to cut curved lines.
Courtesy of Union Carbide Corporation, Linde Division

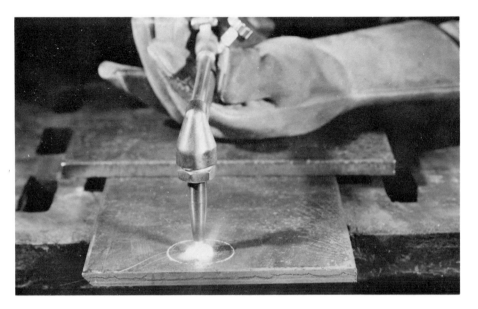

Fig. 71B. *Courtesy of Union Carbide Corporation, Linde Division*

Forging

Red-hot metals can be hammered into any shape (see Fig. 72). We have all seen pictures of the brawny blacksmith working at his forge holding a piece of iron with a pair of tongs in one hand while hammering the hot metal against an anvil with the other hand.

The torch can effectively replace the glowing furnace of the forge, and a foot length of railroad track purchased at the local scrap-iron yard will do very well as an anvil. A flat-head hammer and a ball peen hammer are the only other tools needed for most of the forge-hammering you will have to perform.

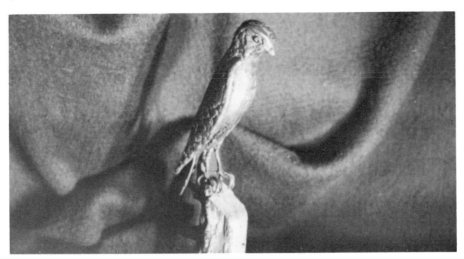

Fig. 72. A bird of forged and welded iron pipe sculpted by Hans Schweizer.

Beading a Weld

When solids are being used in a sculpture and it is necessary to join them together or to join them to other parts of the sculpture, it is usually necessary to add the metal of a welding rod to the joining point. This beading process is somewhat similar to the process of using a needle and thread.

With practice, an even seam of melted steel beads "sews" the solid steel to its adjoining piece. Move the end of the rod along, closely following the flame of the torch as it heats the unjoined edges to a cherry red and brings the metal to the fusing point (see Figs. 73 and 74).

The following photographs (Figs. 75A-82B) illustrate sculptures whose creation involved the use of the basic steel welding processes with which you are now acquainted. Take a few minutes to look closely at the makeup of these pieces before you move on to the rest of the book.

84

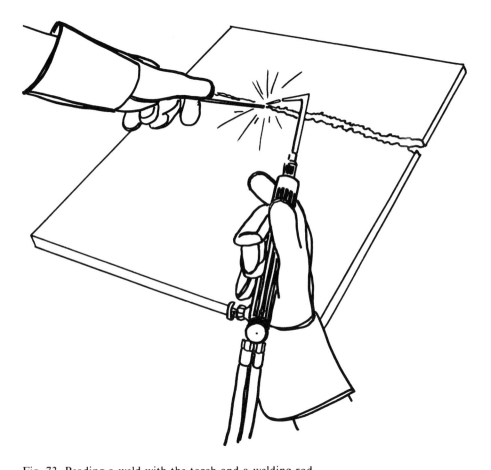

Fig. 73. Beading a weld with the torch and a welding rod.

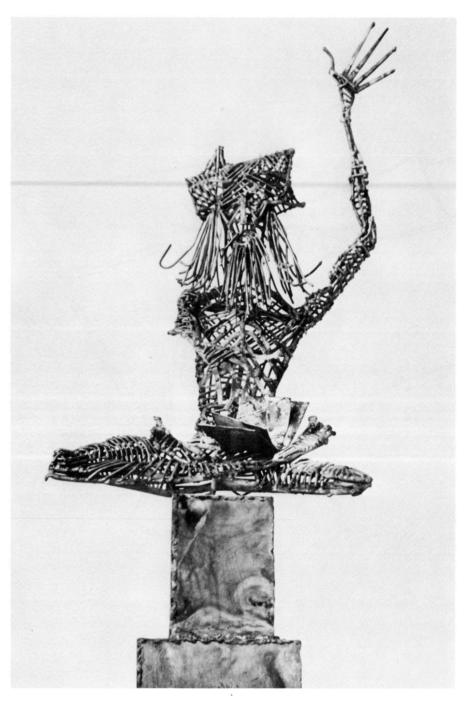

Fig. 74. The base of this piece was made by using the beading process to join the metal plates. The beads can be seen on the left of the base. *Guru* by the author.

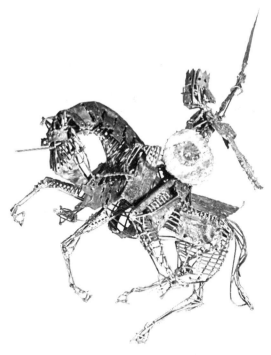

Fig. 75A. Two views of a sculpture by the author showing the use of lines and solids.

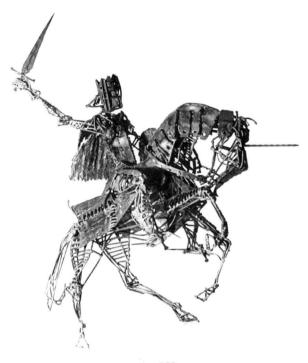

Fig. 75B.

87

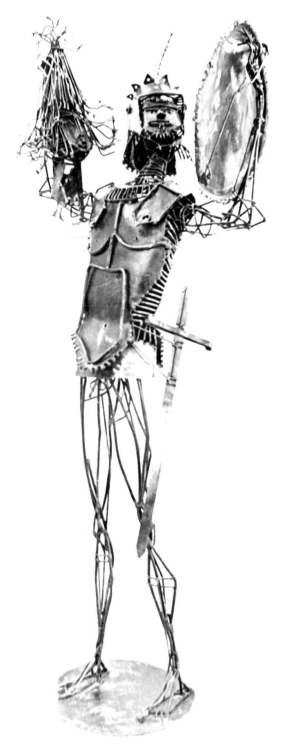

Fig. 76. The author's *Perseus* also shows how effective a contrast between lines and solid planes can be.
Photo by Anne Caffrey

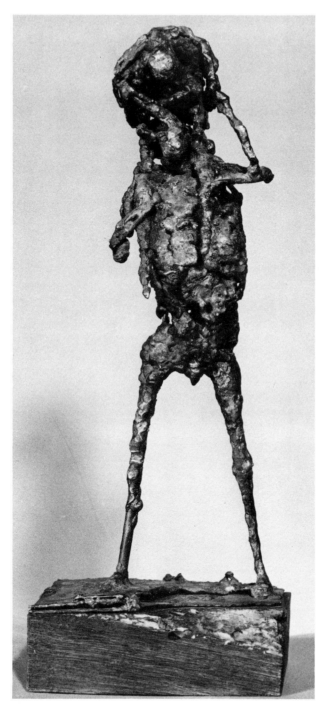

Fig. 77. *The Survivors,* a 14 inch high welded steel sculpture by James Pinto. Drips of molten steel were used to build up the solid areas.

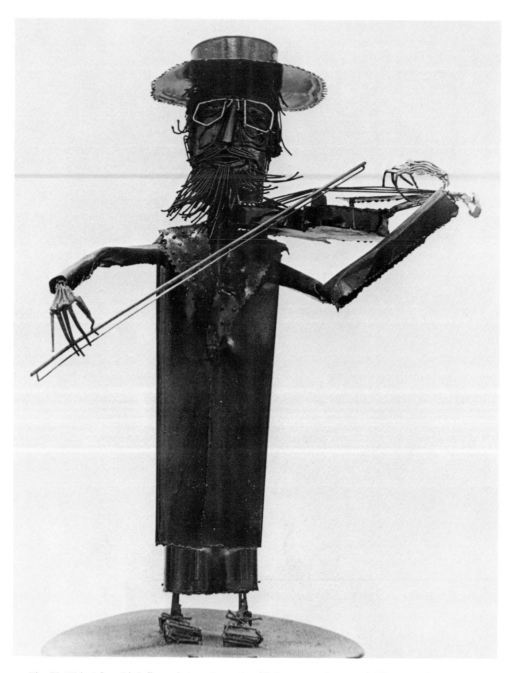

Fig. 78. This 4 foot high figure is largely made of light-gauge sheet steel. The coat, sleeves and trousers were easily rolled by hand into the desired shapes and then joined at the seams with the torch flame. The hair, hands, glasses, violin strings and bow were made of welding rods. *Fiddler* by the author.

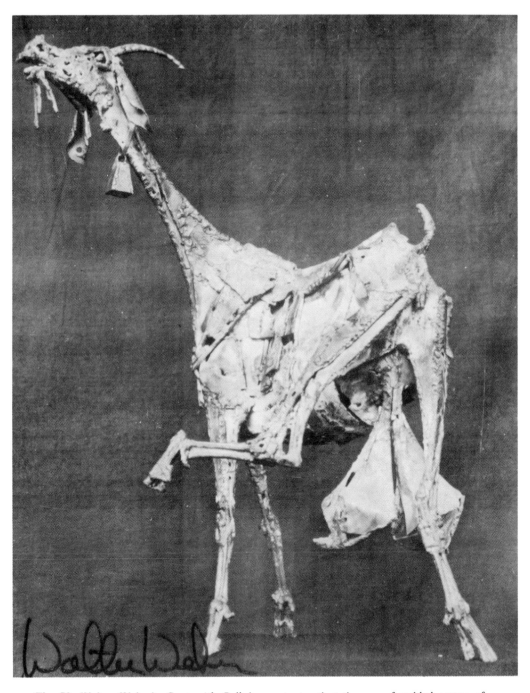

Fig. 79. Walter Weber's *Goat with Bell* demonstrates that the use of welded scraps of irregularly shaped metal doesn't preclude the creation of subtle forms.

91

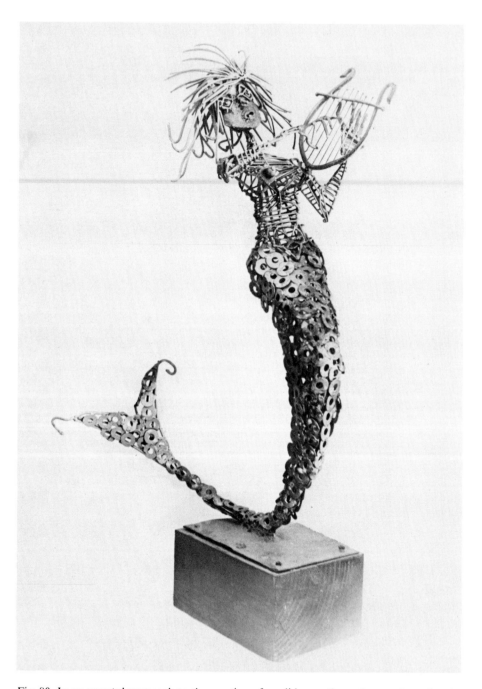

Fig. 80. In an unusual approach to the creation of a solid area, the author used overlapping washers to represent the scales on the tail of his *Mermaid*.
Photo by Anne Caffrey

92

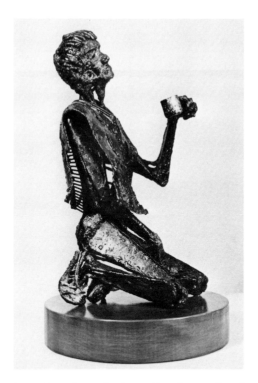

Fig. 81A. These two views of a sculpture by Angus Kent Lamar show how he shapes, textures and patinas heavy-gauge steel into figures of great dramatic impact.

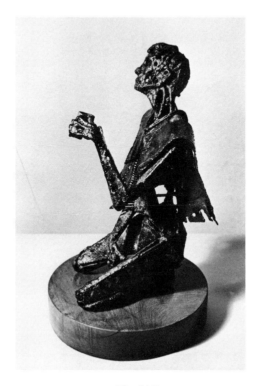

Fig. 81B.

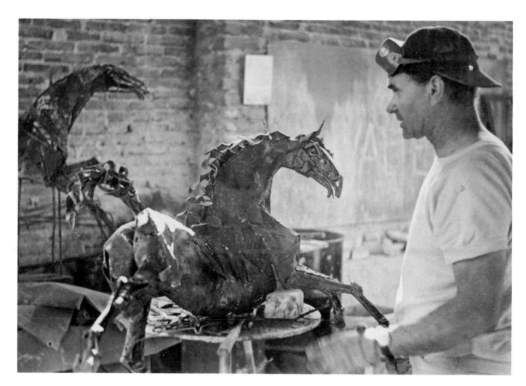

Fig. 82A. Two of Walter Weber's magnificent horse sculptures. The covering of steel plates is welded with such understanding of the vital anatomy of the horse that none of the dynamic qualities of this beautiful animal are lost.

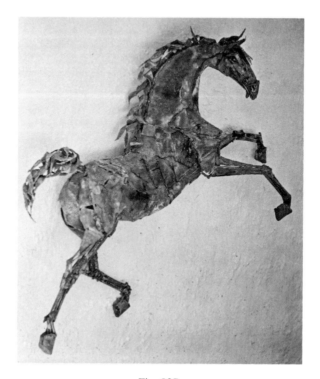

Fig. 82B.

Brazing

Ferrous metals are those derived from or containing iron. Up to this point we have been discussing only the processes of joining two such metals—steel in particular—by the fusion method, i.e., that of using the oxyacetylene torch to melt the edges of the pieces of metal until they flow together and make one piece. In some cases, metal from welding rods was added to the edges to further strengthen the joints, but this, too, comes under the heading of the fusion method.

Brazing is another method of joining metal parts—one that does not require the melting together of those parts. Joints made by using the brazing method have great strength, for they are made by using bronze rods as the additive, and bronze rods melt at a considerably lower heat than steel. A bronze rod will effectively join two metals that may have a far higher melting point than the bronze itself.

In order to braze-weld with a bronze rod a flux must be used. This type of flux is available in either powder or paste form and can be purchased at any welding supply house. Be sure to ask for and get the flux used for brazing as there are other types of flux which are only suitable for soldering.

To join two pieces of metal that have a higher melting point than the bronze rod, simply preheat the rod with the torch and dip it into the can of flux before applying it to the metals that are being joined.

Brazing rods may also be used to coat areas of iron or steel sculpture with bronze. The usage of this technique will add color and a special texture to

your sculpture. Not only can you produce a highly decorative patina on the steel surface with your brazing rod for as you become more adept in its use, you will find that you can also control the drawing of decorative three-dimensional forms on the steel surface by flowing the molten metal in various thicknesses and planned designs.

Use the torch to preheat the surface of the iron or steel until it glows orange-red. Then apply the brazing rod and the torch simultaneously to the preheated surface. The bronze will soon begin to flow, producing a beautiful patina. For brazing, the heat of the flame should be less than that used in welding steel to steel as bronze melts more quickly than steel and will become too liquid under too intense a flame.

Copper Sculpture

Copper is a beautiful metal and sculpture executed in welded copper is often beautiful in color (see Fig. 83). The heat of the torch causes the natural copper color to change, and the combination of the natural color and these beautiful and varied hues can be magnificent.

The special properties of copper make it require a somewhat different welding process from that used for welding iron or steel. When the torch is applied to copper it will redden and then suddenly melt, whereas steel and iron turn red slowly and become pasty before they liquefy.

To weld joints of copper pieces, a bronze brazing rod is required. You can buy these rods already coated with flux. If you use a plain rod the working end must be preheated and dipped into the flux each time before you use it.

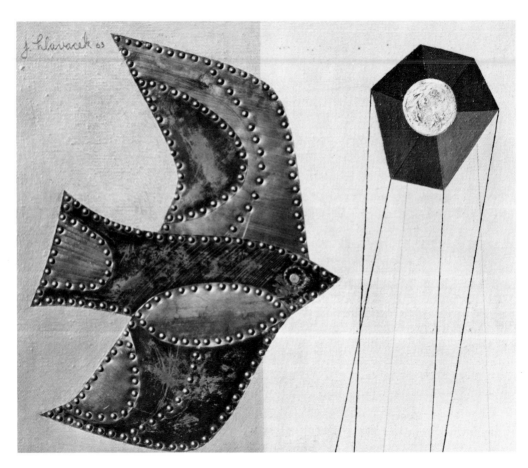

Fig. 83. J. Hlavacek's copper and brass bird was mounted on canvas and combined with oil paints to create *Paper Moon*. This piece measures 9½ by 11½ inches.

Brass Sculpture

Brass is a combination of copper and zinc and has a lower melting point than steel. Therefore, for welding brass sculpture, somewhat less heat should be employed than for steel welding.

At its melting point, zinc emits fumes which, if inhaled, may be nauseating. Thus, when you're working with brass it is advisable not to bend over the welding as you work or to get very close to it.

There are special brazing rods suitable for welding brass. One such is Oxweld® No. 25M, but if you can't find this one, ask your dealer for others. Flux is also required. Your supplier will sell the variety especially suited to welding brass, or you can buy bronze welding rods coated with brazing flux.

Figures 84-90 illustrate a series of inventive and witty pieces, the work of James Turnbull, created from bronze rods and cut sheets of bronze and brass. In some cases, the surface color and texture were created by brazing with silver brazing rods. Due to the pliant nature of the rods and the delicate balance of the weights of the forms, the various parts of these sculptures will move with the breeze or a light touch.

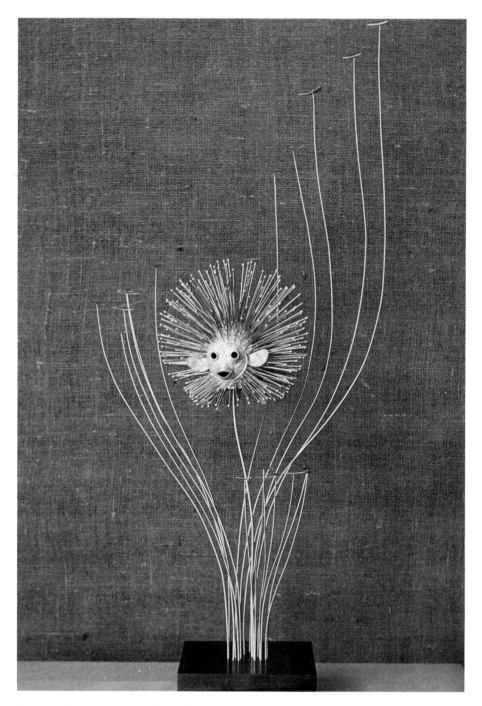

Fig. 84. *Blow Fish*. James Turnbull.

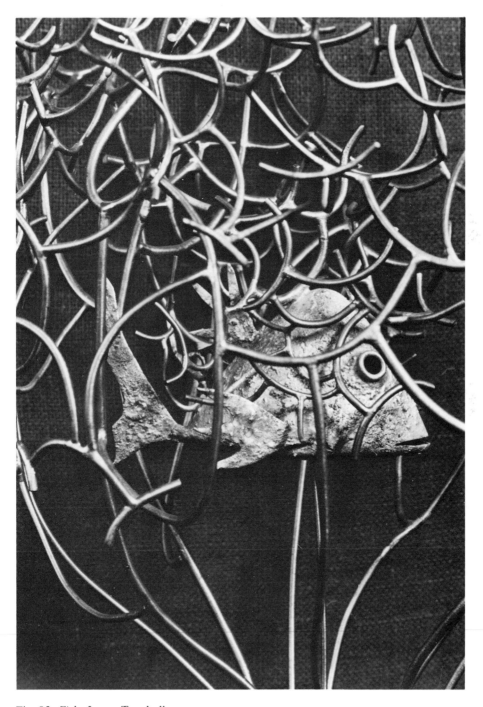

Fig. 85. *Fish*. James Turnbull.

Fig. 86. *Bird*. James Turnbull.

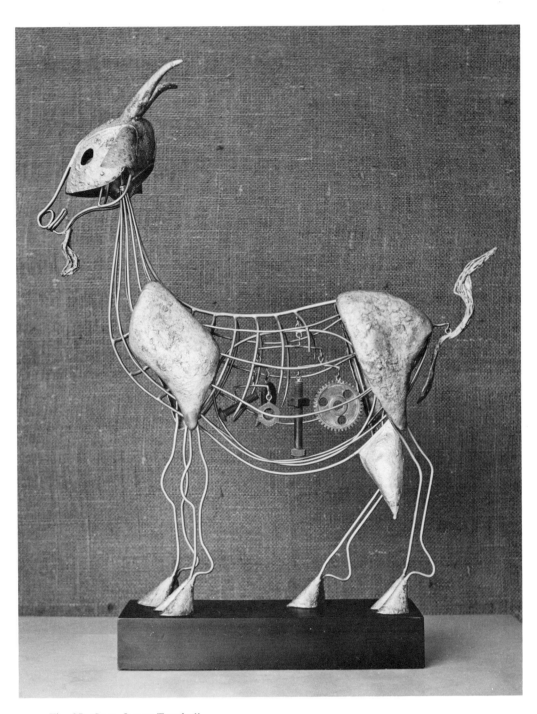

Fig. 87. *Goat*. James Turnbull.

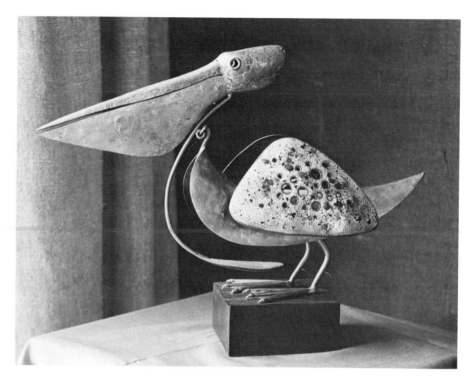

Fig. 88. *Pelican*. James Turnbull.

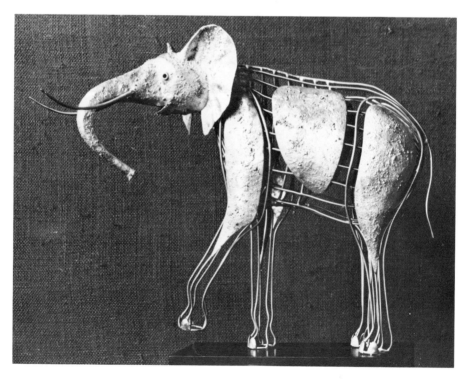

Fig. 89. *Elephant*. James Turnbull.

Fig. 90. *Birds*. James Turnbull.

KAFKA'S CASTLE

The inspiration for *Kafka's Castle* came from the intriguing shape of a loosely rolled sheet of light-gauge brass that originally measured four feet by eight feet (see Fig. 91 and color section). I had "cannibalized" the sheet as I cut large and small pieces from it for various welding purposes. The resultant form was an eight foot roll of sheet brass which suggested towers, battlements, crenellations and tessellations (see Fig. 92). The piece was just waiting for the sculptural play which would eventually turn it into my concept of *Kafka's Castle*, the remote and menacing fortress which controlled the destiny of the hapless character created by Kafka in his great novel *The Castle*.

I decided that the basic metal form would have its qualities of strength and mystery enhanced by the addition of rods jutting symmetrically and rhythmically in patterns of winding and curving lines (see Fig. 93). These would suggest labyrinthian depths and spidery traps leading to the interior of the mysterious castle. The close-ups of *Kafka's Castle* in Figures 94-97 show how the rods were placed and worked into the brass "base."

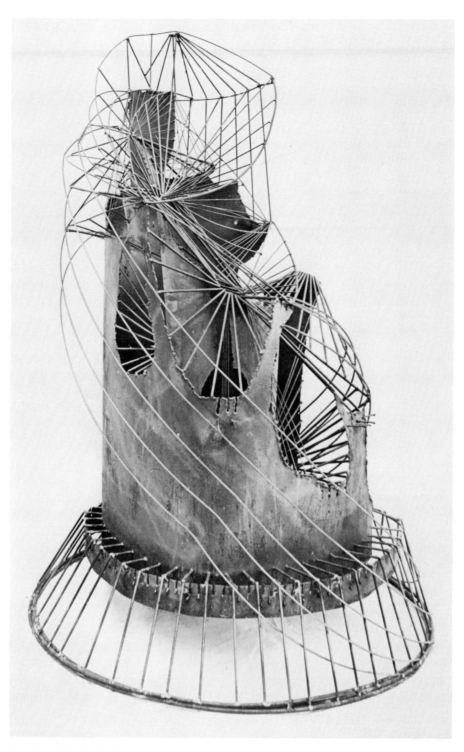

Fig. 91. *Kafka's Castle* by the author.
Photo by Anne Caffrey

107

Fig. 92. A rough sketch of the sheet of brass that suggested an old castle and provided the base for the ultimate concept.

Fig. 93. A rough working drawing that was made as the idea for the spidery additions of rod and wire developed.

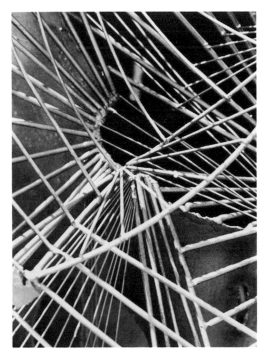

Fig. 94. Four details of *Kafka's Castle*.
Photo by Alex Apostolides

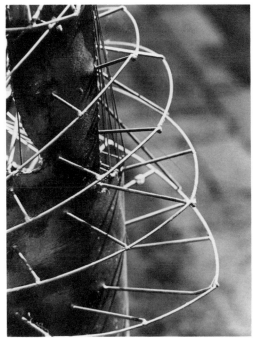

Fig. 95. *Photo by Alex Apostolides*

109

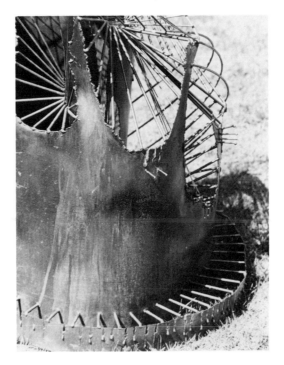

Fig. 96. *Photo by Alex Apostolides*

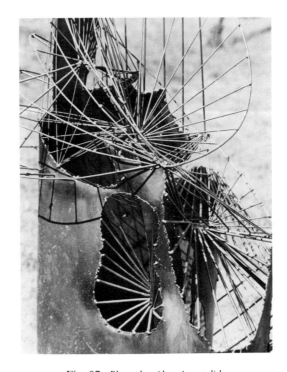

Fig. 97. *Photo by Alex Apostolides*

110

Large
Sculptures

One of the pleasures of the metal welding process is the comparative ease involved in the construction of large sculptures (see Fig. 98 and color section). Unlike the laborious process of carving huge stone chunks or half tree trunks, metal may be easily welded piece by piece into monolithic forms or figures. If the resultant sculptures are properly treated against rust and the wear of climate changes, they may become permanent outdoor pieces. Properly balanced and firmly secured on legs, or fixed into concrete or metal bases, welded forms may tower and jut in shapes impractical in stone and wood, and prohibitively expensive in cast metals.

The strength and gauge of the rods and sheet metal used depends, of course, on the ultimate concept. If forms six feet long are required to extend unbalanced from the base, metal of sufficient weight and tensile strength is required, both for the supporting forms and the extended ones. On the other hand, shapes of dynamic design may be achieved by utilizing the laws of balance and counter balance which will permit the use of light-gauge rods of metal in sufficient quantity to produce a large, striking sculpture.

Metals melt and tarnish with exposure to the elements. Iron, steel and most other metals used in welding sculpture must be painted or heavily varnished to resist weathering. Patinas achieved on metals with the torch flame are often very beautiful and still retain that beauty when covered with a heavy, transparent varnish.

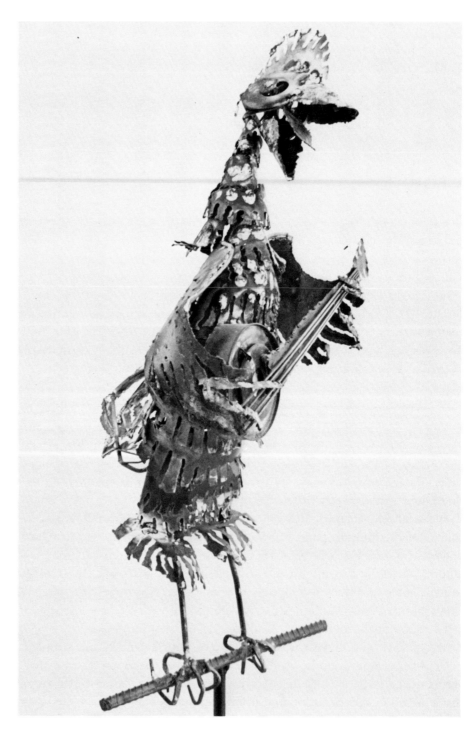

Fig. 98. A large sculpture of a bird, created by the author, meant to be placed outdoors.
Photo by Anne Caffrey

Stainless steel is frequently used by contemporary sculptors, but as far as this author is concerned, it lacks the natural beauty of the less synthetic materials. A stainless steel sculpture does not require the application of a protective coating.

A FOUNTAIN SCULPTURE

This tall bird (see Figs. 99 and 100), of an unclassified species, was planned to stand in the basin of a garden fountain, hence the very long legs. The feet were welded to a heavy sheet of iron which was then covered with small boulders to retain the natural look suitable to the fountain.

Subjected to the constant spray of the fountain and immersion in water, this steel bird had to be doubly protected against rust and corrosion. It was treated with extra-heavy outdoor varnish and rust preventing paint. However, as with any metal subjected to constant dampness, periodic recoating, at least once a year, is necessary.

"DON QUIXOTE AND SANCHO PANZA"

Don Quixote and Sancho Panza are two 3/4 life-sized figures, the Don on his aged Rosinante and Sancho on his burro (see Figs. 101, 102 and 103). Each stands on four feet, so there were no problems of balance and counterbalance. There was, however, the relatively simple problem of supporting the increasing weights of the figures on the slim legs of the animals. This called for adding strength to these supports and finally, on Don Quixote's horse, adding slim rods of steel going from hoof to hoof.

Notice the variation of line and solid form. Such play gives lightness and movement to the sculpture, keeping the feeling of a drawing in steel.

The figures were treated with black outdoor paints containing anti-rust agents and also given several coats of clear varnish. This protection lasts about a year outdoors and should be repeated when tarnish begins to appear.

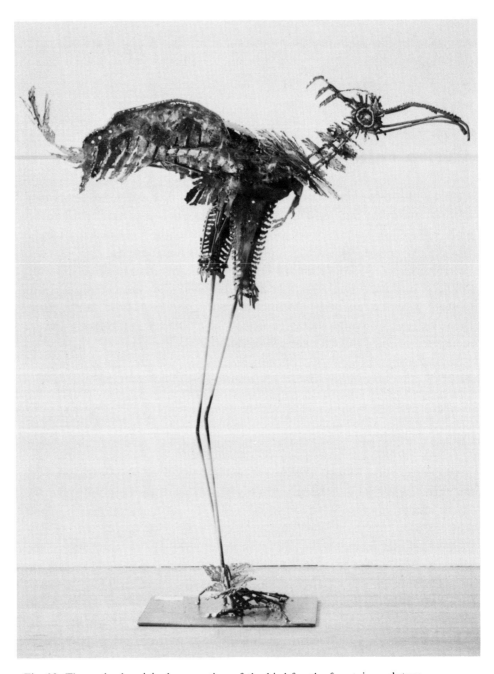

Fig. 99. The author's original conception of the bird for the fountain sculpture.

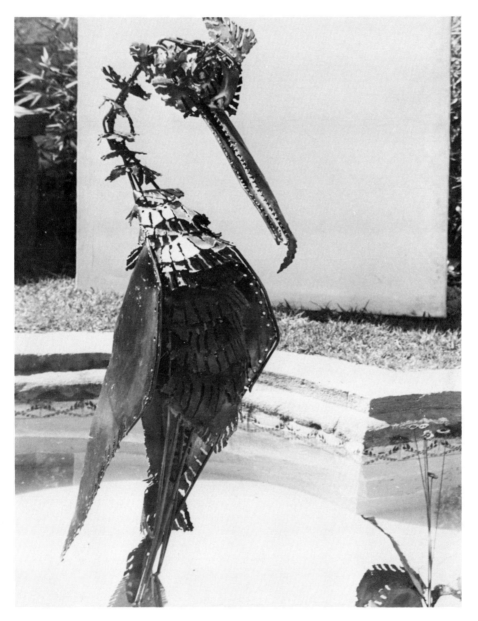

Fig. 100. The completed fountain sculpture. Note the major changes in the legs, wings and position of the body. Changes such as these would not be possible in any of the traditional sculpting materials.
Photo by Alex Apostolides

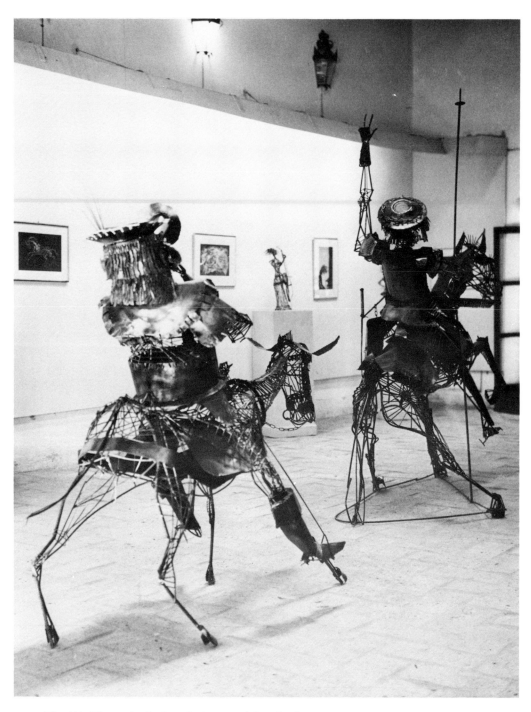

Fig. 101. The author's *Don Quixote and Sancho Panza.*

116

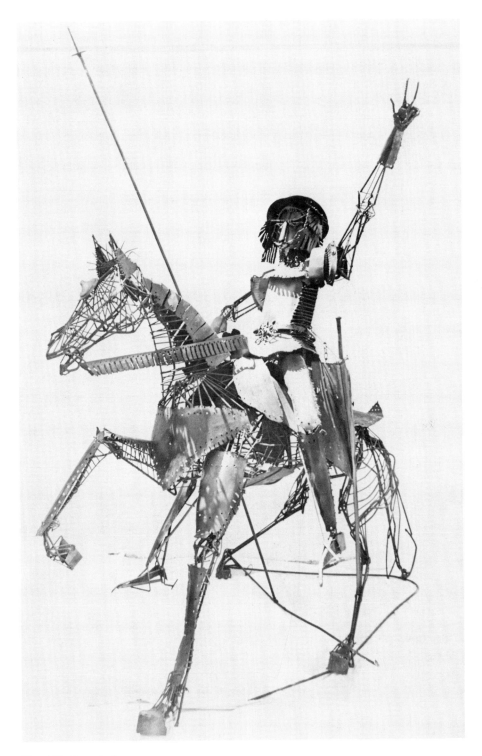

Fig. 102. *Don Quixote.*
Photo by Anne Caffrey

117

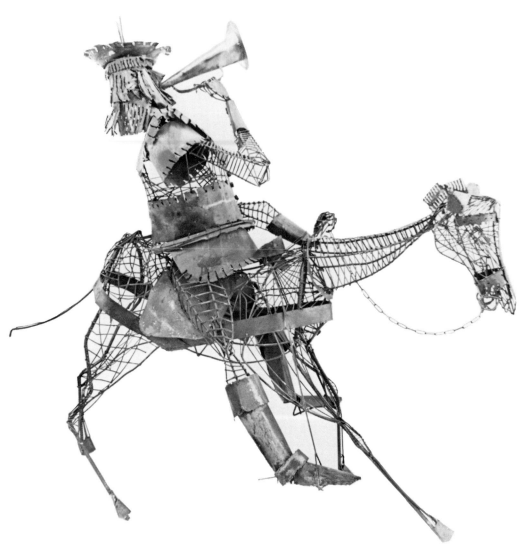

Fig. 103. *Sancho Panza.*
Photo by Anne Caffrey

118

"HOMAGE TO MICHELANGELO"

This life-sized paraphrase in steel of the Michelangelo *Pietà* was a challenge which called for delicate welding (see Figs. 104, 105, 106 and color section). In order to produce the folds and whorls of the Madonna's dress and headdress, a very light-gauge steel sheet was used. Such light steel burns through at the touch of the oxyacetylene flame and great care must be taken in joining one piece to another.

These forms of light steel were joined by dint of practice in making delicate welds using minimal heat. Concentric circles of 1/4 inch steel wire and some straight metal rods enhanced the impression of softness in the skirt, contrasting with the stark, limp body of the Christ figure.

Bending the very light-gauge steel to form the recumbent body of the figure of Jesus did not require the heat of the torch. The thin steel sheets were bent and shaped by hand and wrapped around a basic armature of 1/4 inch steel rods, some of which are shown protruding in these photos of the work in progress. The wide skirt of the Madonna was also hand bent. The many seams where the steel sheets joined required welding.

When the solid forms were completed a series of steel rods and steel wire in rhythmic patterns accentuated the soft folds of the Madonna's dress and headdress.

Because of the thin character of the steel used the welds had to be done with the minimal heat-producing mixture of the torch. This large piece weighs no more than about sixty pounds, a feat of weight conservation not possible in any other permanent sculptural medium.

"PERSEUS"

Perseus, standing straddle-legged with arms outstretched and holding relatively equal weights, presented almost no problems in support (see Fig. 107). Welded to a base made of a ring of steel, this quite heavy figure may be rolled about to any location with ease.

As an example of the welder's opportunity to use found objects, the shield of *Perseus* is a child's snow-sliding toy and the hair of Medusa is a twisted batch of tie-wire found in a steel supplier's junk heap.

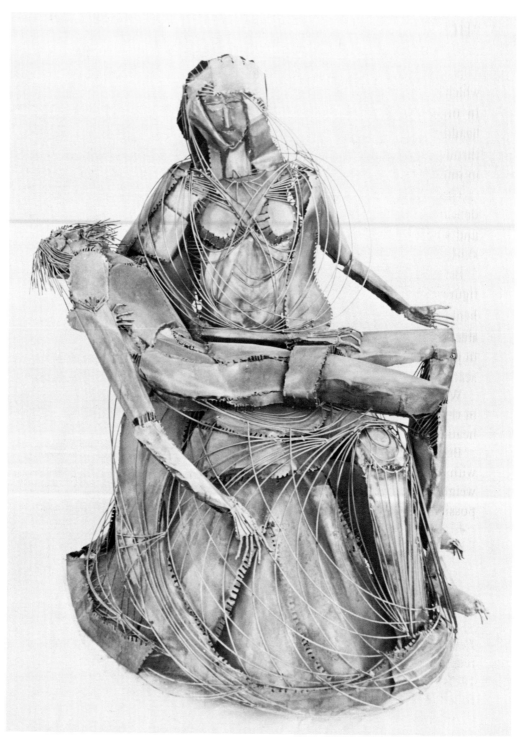

Fig. 104. The author's *Homage to Michelangelo*.
Photo by Anne Caffrey

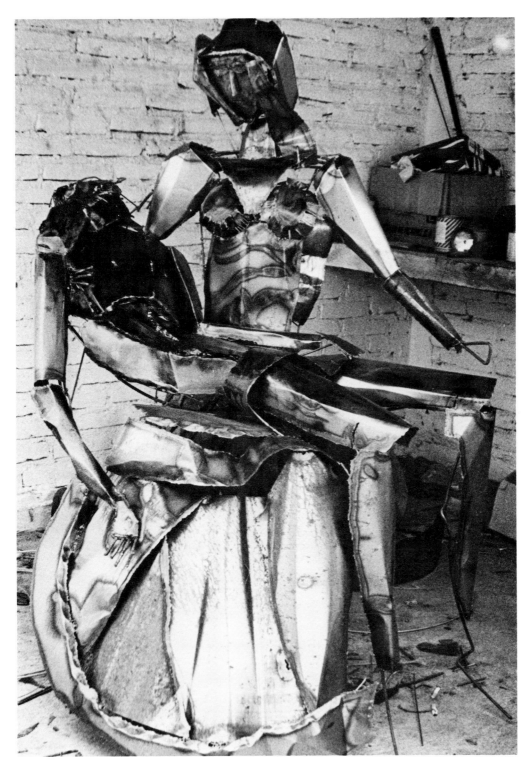

Fig. 105. *Homage to Michelangelo* in process.

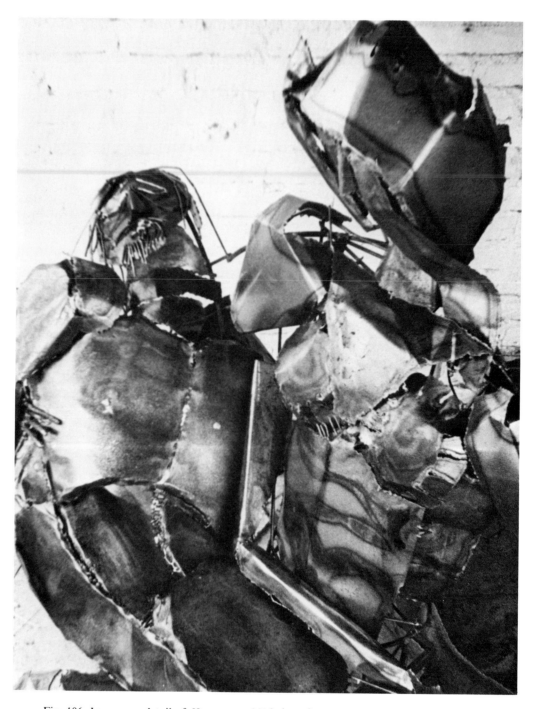

Fig. 106. In process detail of *Homage to Michelangelo*.

122

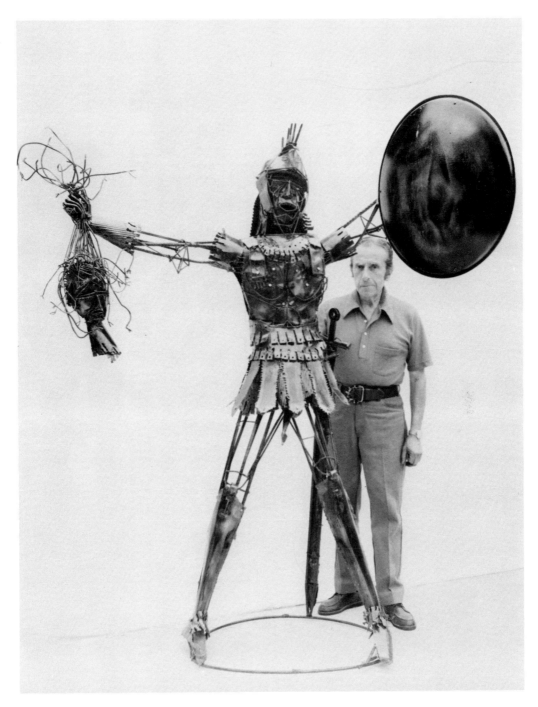

Fig. 107. *Perseus* by the author.

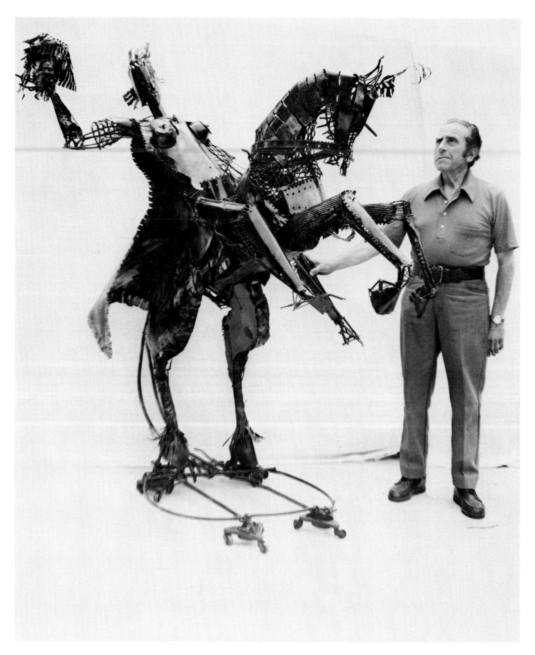

Fig. 108. The author with his *Salome Militant*.
Photo by Cathy Fisher

124

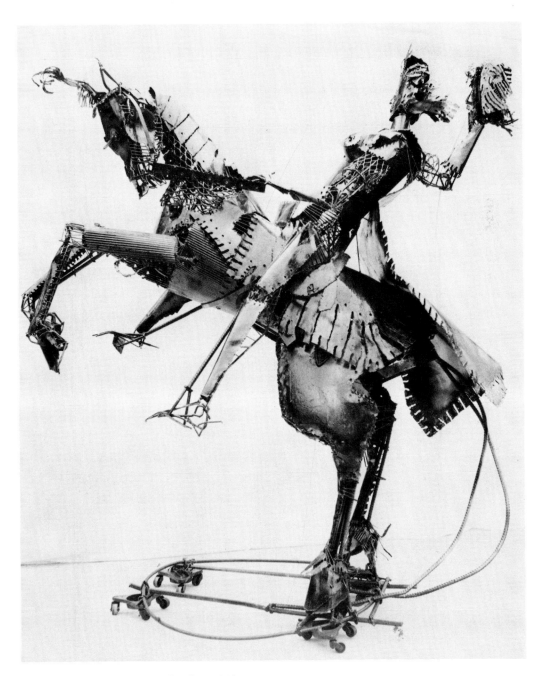

Fig. 109. Another view of *Salome Militant.*

125

"SALOME MILITANT"

Here is an example of a huge piece of sculpture which called for balancing in addition to strong supporting metal (see Figs. 108 and 109). Notice that the rearing horse is counterbalanced by the figure of *Salome* leaning back. The hind legs of the horse were reinforced with steel rods that were heavier than those used in the forelegs. The impression of equal thickness was retained by putting rounded sheets of light-gauge steel on the forelegs.

A welder must use his ingenuity in order to make heavy sculptural pieces easy to handle. This huge piece (I had myself photographed beside it to indicate its proportions) became movable when balanced on a steel hoop to which a set of piano casters had been attached.

The great contribution of the "modern" viewpoint in art, that of not requiring the artist to be realistic to the point of photographic exactness, allowed for the interplay between the openwork steel mesh and the severe solids, which added lightness and movement to the whole concept.

It is only proper to complete this section on large sculptures with a piece which is unlike any of the others pictured here, James Pinto's abstract mural sculpture (see Fig. 110).

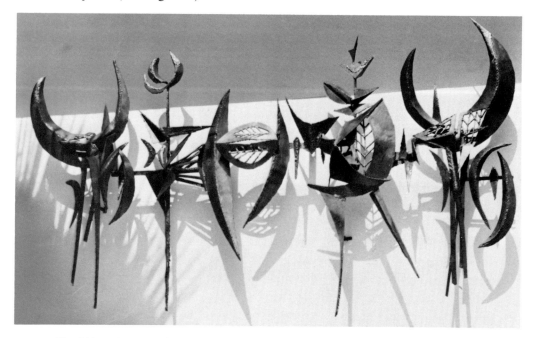

Fig. 110. A dynamic piece by James Pinto which is a fine example of an abstract design in steel. This large, decorative, outdoor mural sculpture is 9½ feet long and 4 feet high.

Bases

A permanent base should be worthy of your finished sculpture and the choice of material for it will require thought. Choose carefully and in accordance with your subject. There are many materials available, ranging from smooth marble to rough stone and from wood in its rough, natural state to a highly polished hardwood.

When you began your sculpture, you welded the footing to a temporary base of light-gauge steel. It is now time to remove that base. Use the torch to soften the welded connection so that the figure can be pried loose from the temporary base. Prop the figure in a position which will allow you easy access to the bottom of the sculpture, and then weld bolt heads to it (see Fig. 111). Now stand the sculpture, resting on its bolts, on top of the permanent base. Make sure that the sculpture is in its final position. Draw around the bolts on the base as a guide for boring holes into it. Someone else should probably help you, either by steadying the figure or by doing the drawing.

With a bit in a hand or power drill (use a bit a trifle larger than the bolts and one suitable for boring into the material of the new base), drill small holes completely through the base. Try the sculpture and the bolts in the holes to make sure that they fit and are correctly placed. Now, using a larger bit, about a half-inch larger in diameter than that used for the bolt holes, drill holes on the underside of the base, using the holes already drilled into the top as your guide. These countersunk holes should go deep enough into the base to allow you to affix nuts to the bolts which are attached to the bottom of your sculpture.

Place your sculpture on the base, inserting the bolts into the holes that were drilled for them. Now insert the nuts from underneath and firmly tighten them. Your sculpture is now permanently set on its base.

The sculptures pictured in Figures 112-118 well illustrate how much a permanent base can add to a finished piece.

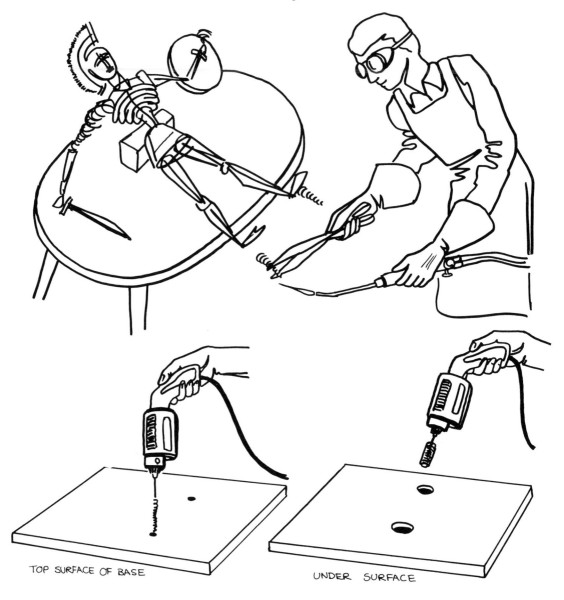

TOP SURFACE OF BASE

UNDER SURFACE

Fig. 111. Preparing the sculpture and the permanent base for joining.

128

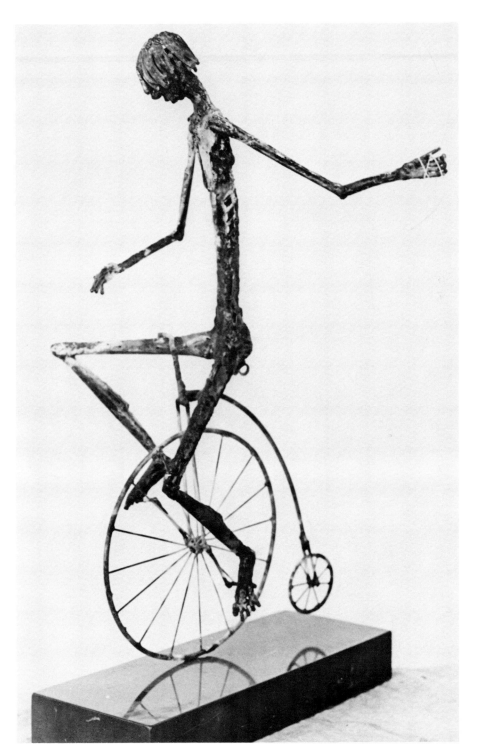

Fig. 112. A charmingly balanced sculpture in steel by Walter Weber. Notice how the wheel
has been affixed to the marble base.
Photo by Barbara Kyrcz

Fig. 113. A series of pieces in welded steel by Frank W. Gerrietts. The decorative areas of brazing were created by the use of bronze rods dipped in brazing flux. The use of marble for the bases and the table top adds elegance to these fine sculptures.
Photo by A. W. Ellsworth

Fig. 114. *Photo by A.W. Ellsworth*

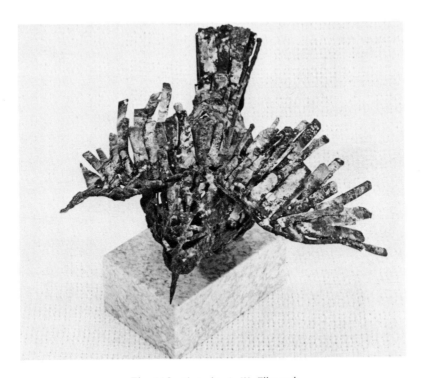

Fig. 115. *Photo by A. W. Ellsworth*

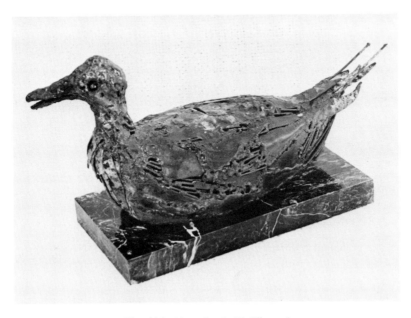

Fig. 116. *Photo by A. W. Ellsworth*

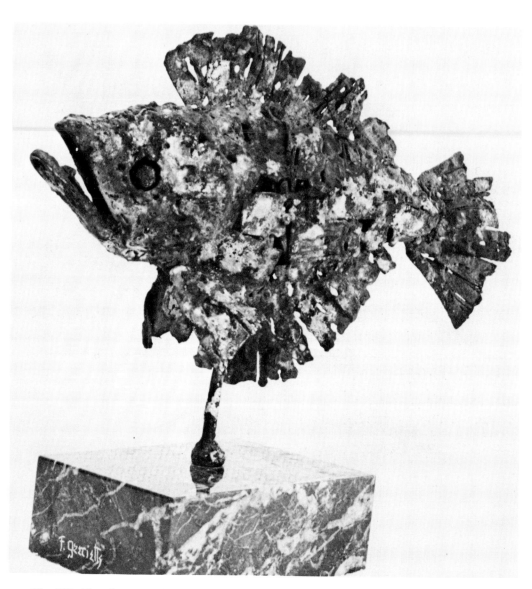

Fig. 117. *Photo by A. W. Ellsworth*

132

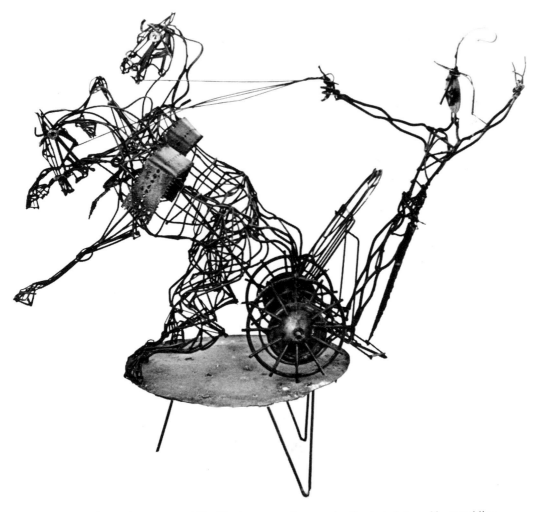

Fig. 118. The author mounted his *Charioteer* on a base made of a steel plate and bent welding rods.
Photo by Anne Caffrey

Bibliography

Barr, Alfred H. *Cubism and Abstract Art*. Repr. of 1936 ed. New York: Arno, 1967.

————. *Picasso: Fifty Years of His Art*. Repr. of 1955 ed. New York: Arno, 1967.

Kultermann, Udo. *New Sculpture: Environments and Assemblages*. New York: Praeger, 1968.

Meilach, Dona and Donald Seiden. *Direct Metal Sculpture: Creative Techniques and Appreciation*. New York: Crown, 1966.

Read, Herbert. *Concise History of Modern Sculpture*. New York: Praeger, 1964.

————. *Art Now: An Introduction to the Theory of Modern Painting and Sculpture*. London: Faber & Faber, 1960.

Ritchie, Andrew C. *Sculpture of the Twentieth Century*. Repr. of 1952 ed. New York: Arno, 1972.

Union Carbide Corporation, Linde Division. *The Oxyacetylene Handbook*. New York: Union Carbide, 1969.

Wilenski, Reginald H. *The Meaning of Modern Sculpture*. Boston: Beacon, 1961.

Index

(Page numbers in **bold face** refer to illustrations)

Arthur Zaidenberg

I was born in Brooklyn, New York and began drawing at a very early age. My formal art training began at the National Academy and the Art Students League in New York. At the age of eighteen I went to Paris and studied at the Beaux Arts and with André L'Hote. Upon returning to the United States I illustrated several books including *Candide, Against the Grain* and *Thais.*

I have had many one-man shows of my work in various media at the AAA and ACA Galleries in New York City and at several galleries in Mexico. I have also shown in many foreign countries in seven trips around the world. My works are in the permanent collections of the Metropolitan Museum, the Brooklyn Museum and the New York Public Library as well as private collections throughout the world.

Creating metal sculpture now absorbs most of my interest, though I still enjoy doing murals, the most recent of which was for a public room on the *S. S. Rotterdam.*

Editor's note: Mr. Zaidenberg has a wide reputation as a painter, teacher, lecturer and author. He lives in Woodstock, New York and San Miguel, Mexico with his wife, Tommy.